STONE GIRL E-PIC

Ed Baker

STONE GIRL / E-PIC

Ed Baker

Published in 2011 by Leafe Press, Nottingham (England) and Claremont (California).

ISBN: 978-0-9561919-6-0

Foreword

"It is important to collect these writers because, as has been the case over and over in the history of literature, the best and most innovative writing, the writing that advances the art and that in the future becomes the classic and defining work of a period, is almost always the work of outsiders."

 (Dr. John M. Bennett, Curator of the Avant Writing Collection at Ohio State U.)

<div align="center">

all

is
just

so

let

it

</div>

(Ed Baker, from G OO DNIGHT)

Since readers of Ed Baker's *Stone Girl E-pic 1-5 (SG)* have already the work in front of them, I won't talk about it in my introduction to the visual and minimalist work of this remarkable American poet. I'd prefer to share observations I've already made in other places about two of his smaller works not included in his *SG: Things Just Come Through* (Red Ochre Press, 2005) and *DE:SIRE IS* (The Knives Forks and Spoons Press, 2010), hoping in this way to provide both context and appreciation for a unique artist and a unique style. It's my hope that the similarities between them will become apparent as well as the primary reasons why I believe Baker's major work is a landmark in contemporary visual poetry. SG represents a genre purity most practitioners of visual poetry seem to have strayed from: a combination of haiku-inspired minimalist writing, Eastern calligraphy and the artist's penchant for choosing the right material.

Ed Baker, Bob Grumman, Jeremy Seligson and all the contemporary practitioners of what I call a more classical visual poetry have had to share the stage with Vispo for at least two decades now ('Vispo' being shorthand for a computer-generated type of work that can be easily interchangeable with all of its other kinetic, aural and textual hybrids).

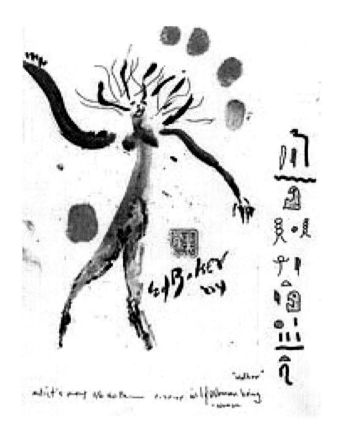

Though Baker himself resists any labeling, saying to me in personal correspondence that "as for me I reside in the I-just-don't-know" school The Nopo school!" I can't help feeling there are significant differences, if only one. And I'm inclined to believe that one lies in a growing discrepancy, fuelled solely by Internet technology, between the way visual art's produced and its genre purity. Perhaps I'm a little dismayed also at how unevenly the two are being presented, as if visual poetry is almost becoming synonymous with, or even eclipsed by, Vispo (which it certainly isn't). But I choose to refer to the Baker style of minimalist/visual poetry as 'pure'.

I also choose to speak of genre purity as meaning primarily textual production and accompanying visual effects, two essential components of every single artifact. Visual poetry today, both the digital and traditional kinds, combine both in complementary and also more interestingly contrastive ways. With the result that two types of visual poetry seem to occupy the same writing space. While 'Vispo' can be stated in purely technical terms (media poetry and fiction" born to pixels rather than the page", as Robert Kendall says of his work in Word Circuits at http://www.wordcircuits.com, traditional visual poetry (in my view) has to restrict itself to a purely verbal (and even pictorial) representation of technique & the classical forms on which it relies.

Don Wentworth's Issa's Untidy Hut: The Poetry Blog for Lilliput Review at http://lilliputreview.blogspot.com is an example of an online forum for haiku-based poetics that's traditional in outlook and presentation. Any discussion, therefore, of the differences between Vispo and classical visual poetry amounts to an understanding of what's always been a technology and culture bifurcation at work in every artistic production. I'm making the point that Baker's work, always truer to a classical impetus, has less of a cultural divide to worry about.

What's at stake (in my view) is the changing form & content of visual poetics itself that's been forced by Vispo on all practitioners. I also wonder whether, indeed, older models haven't been already relegated to an outmoded "bastarda gothic" in the light of a computer-generated language of pure interactivity. It's perhaps the same sort of fundamentally transformed notion of literacy that took place after Gutenberg and the spread of print literacy. Digital technology has only magnified the split between, on the one hand, original haiku-inspired art and accompanying visual representations of the surrounding world (perhaps a form more properly akin to 'Haiga'), with technology comprising of brush- or pen-strokes on a page, calligraphy, typographic designs or even simple spacing. And, on the other, a text wholly derived from multimedia software that's produced primarily by poet-technicians intent on exploiting all the possible applications of Web 2.0, an art form that pays as much attention to production techniques as literary form itself. The former oftentimes grossly overshadowing the latter. Jim Rosenberg's Poetries, for example, at http://www.well.com/user/jer showcases both interactive & hypertextual ingenuity.

Perhaps nothing has better illustrated this growing technique and artistic integrity dissonance ("dissemblance" is a term philosopher & cultural theorist Jacques Rancière might have used) than the recent online controversy over the way editors Curtis Faville and Robert Grenier formatted the text of Larry Eigner's poetry (at http://stevenfama.blogspot.com/2010/03/collected-poems-of-larry-eigner.html) in their *The Collected Poems of Larry Eigner* (Stanford, 2010). Blogger Steven Fama's made the impassioned plea for preserving the integrity of original text at all costs, enjoining editors never to "change the way the poems look on the page, in a way that greatly mars the poetry." He seems to have intuited a great loss to textual integrity in editorial decisions that are not responsive perhaps to the type of visual and typographic settings found on an Eigner page.

I wonder if the same sorts of concerns couldn't be voiced about traditional visual poetry in general? Fama's perhaps sounded a warning to those who would subordinate artistry to means of production only. One we'd be wise to hear. Has there been, in other words, a tendency to conflate techniques of artistic production with art itself, a process abetted by the frenetic deployment of a "hyper-mediatic type of work" (to use Rancière's expression)?

In short, if there are innovators empowered by their technological tools, then who are going to be the cultural gatekeepers? Who are the real predecessors of Vispo whose textual pristineness has been compromised by the rise interactive art? A few (oftentimes unknown) sources of much of what's empowered contemporary Vispo can perhaps be cited, primary among them Henri Michaux, particularly his influential *Darkness Moves*, Fenollosa's *The Chinese Written Character as a Medium for Poetry*, inspiration for Pound's ideogrammatic style, and even the female avant-gardists Hannah Höch and Baroness Elsa von Freytag-Loringhoven from whom Baker says the "Dada Guys...stole lots of 'stuff' "'.

I'm tempted to separate Baker, Grumman and certainly even Michaux and the above-named sources from the digital work of contemporary Vispo artists like Geof Huth, Jim Andrews, & perhaps Gary Barwin. But that would be to make things look too neatly compartmentalized, causing us to overlook the necessary overlaps that always do exist between tradition and innovation. Bob Grumman, for example, has recently told me (in email correspondence) that Geof Huth, among the most active practitioners of interactive poetics, could be characterized as both a "pen-master-a calligrapher, in fact" and a "very digital" artist. John Martone, owner of tel-let (at http://ux1.eiu.edu/~jpmartone/tel/tel.html) a site for a more traditional minimalist writing, can himself alternate gracefully between almost lyrical "dogwood & honeysuckle" verses and more contemporary "visual texts & essays". A careful (and sympathetic) reading of contemporary visual poetry must obviously resist simplistic categorizations and see it as a confluence of many interesting contrastive elements.

Baker's *Things Just Come Through* (Red Ochre Press, 2005) throws into relief the artistry of the classical style as against its more current digital formats: here technique and artifact resulting in poetry that's attributable directly to calligraphy, collage art and minimalist writing style. Carl Rakosi, looking at Baker's 1974 work *The City*, remarked on its "ability to express both vast and complex meanings in a few words" (from Baker-Rakosi mail correspondence reprinted with permission), a literary ideal to which Baker has remained faithful all his life. Dedicated to Cid Corman and offering "special thanks" to HaChungJeanne, Baker's 2005 work is one that homages tradition, muses & visual artistry. The *Korean Spring Orchid* is its subtitle and centerpiece: it is also his friend Sophie Song , with whom Ed wrote the poem's English and Korean versions. A splendid work of artisanal craft and inspiration that issues out of literary & linguistic disciplines.

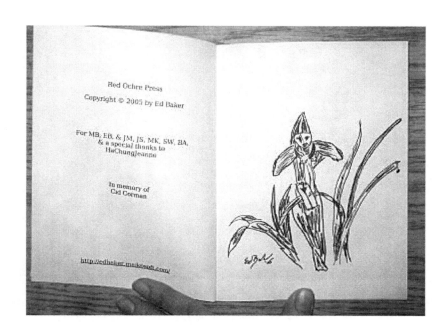

Dedication to Cid Corman

Things Just Come Through could have been handmade: a delicate arti-
fact, wispy & light, to be prized for its aesthetic and textural fea-
tures. I own another edition that has the feel of a Japanese sewn wrap.
Means of production and work (in limited editions) can barely be sepa-
rated. Here's work not made to be retrieved like a Web 2.0 hypertext
poem (even when Baker's work appears online) but offered as a model for
imitation. And it assumes (as all cultural traditions do) a certain
physical initiation into the practice and theory of finely illustrated
poetry, making it both hand-crafted and visual work.

As for methodology, Baker's told me the translating and pen-work al-
ways followed the drawings and poems in English: the whole never to be
seen as a work of translation only. Baker's book is visual literacy *par
excellence* that can't, despite its accessibility; rely on any roman-
ticized "empathetic" qualities of pre-literate eras (as Walter J. Ong
likes to characterize them). The work is classical and spontaneous,
each poem elusive and mysterious on its own and the poet a craftsman
indebted to contemporary masters Soetsu Yanagi (potter and art collec-
tor), Kazuaki Tanahashi (calligrapher) and Hidetaka Ohno (artist).

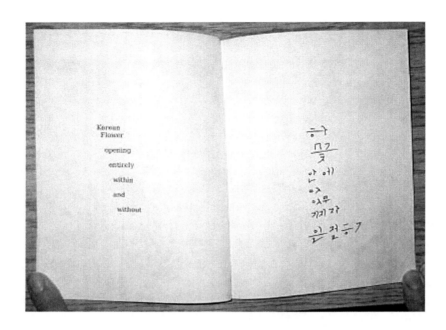

"Korean Flower" poem and calligraphy

Baker has recently celebrated Jeremy Seligson's new book *Cherry Blossoms*, his art & verse on the cover page, calling it "simple, clean, precise", & visible proof that "less is more". The praise is significant. Baker's used the "less is more" language in discussions with me about the work of colleagues & mentors like John Martone, John Perlman and Cid Corman, saying (in his impish way), "I do think that [they] have come to the same "less is more" attitude that Cid embraced INDEPENDENT of Cid maybe parallel to (?) [for] nobody writes/does as/what John M or Cid or me does-did-doing". And what they do is collegial, eclectic and disciplined. And what binds this community of visual artists together is adherence to a principle of exact, finely-crafted verbal economy that's maybe due (at least in the case of Grumman and Baker) to the restrictions of early xerox and mimeo technology as well as an interest in mathematics and electronic technology.

The traditional visual poet means something uniquely different. But what exactly? A question that, of course, can't make sense as long as there's the problem of just what to call it when it appears. Let's say it's art that's indistinguishable from work (or its own productive means), one almost hostilely averse to names. Baker's *Hexapoems*, for example, is an I-Ching inspired work in which a hexapoem (a term Baker coined) refers to a "six-line-poem using chance operationings",

but it's a technique which he dropped in 1973. Though Grumman and Huth have referred to Ed's work as visual haiku ("visku") or even a type of calligrams, after Apollinaire (at http://comprepoetica.com/newblog/blog01361.html), Ed's also refused to call even his haiku-like work haiku at all, and prefers to use a term like "shorties" instead.

He's quipped already about his own allegiances to the "Nopo" school, clearly showing his antipathy towards literary movements and the credentialed set in general: "just remember... nothing much ever happens in a crowd... nothing!" Beginning his career at the "same mimeo xerox typewriter place" as Grumman, (& familiar already with "oscilloscope images and working Sinusoidal Wave stuff" of his electronic technology training), he's acutely aware of production techniques and yet also derides the fondness of contemporary avants for all things digital . When he works he's not afraid to get his hands dirty, maker not just of poems but of pottery, calligraphy, water colors and sculpture. Geof Huth has given a wonderfully detailed description of the art studio that is Ed Baker's entire home, from yard to front porch (at http://dbqp.blogspot.com/2008/11/at-border-of-silver-and-tacky.html).

What is the effect on us of a Baker visual poem (or water color, sculpture, artifact)? Are there any points of intersection with Vispo at all? In his blog article about Baker, Huth makes the following important observation about the man's poetics, & perhaps about all significant artistic expression in which the hand and eye are co-sharers in the work:

Early on in our conversation, Ed said something I had to write down: "Everything comes out of silence and goes back into silence." The two nothingnesses: the time before life, the time after death. And we live between them, so, as we do, we try to make something of that time, we try to make. And that is what Ed does. He makes.

It is perhaps for this reason that Baker can't belong to any noisy literary crowds: the essence of creativity residing in the interregnum between "two nothingnesses". There can't be for him any sign-systems (such as reviewers like me have to use) to get in the way. If we replace language of the image with that of the visual, we might say, with Jacques Rancière, Baker's creations reveal a "double poetics of the image as a cipher of a history written in visible forms and as obtuse reality, impeding meaning and history" (The Future of the Image, 11-12). Meaning a Baker poem, though easily placed within a certain literary American tradition (one that, in my view, follows in a line of descent from Corman, through Oppen and on to Creeley), is primarily and unmistakably an artifact to be made and seen: primarily a "naked, non-signifying presence"(Rancière, 14) that beggars analytic description.

And seen and felt and even heard it certainly must be. Reviewer Joey Madia (at http://newmysticsreviews.blogspot.com/2009/03/building-words-in-time-review-of-ed.html) talks of the "house-building/carpentry" metaphors in Baker's *Restoration Poems:* "The sound of hammer on nail, of plane on plank and the smell of the wood and the land dress the words, which are sparse and carefully chosen." The bare bones bonze at work in a house of art. All the "cut-price mis-mixed paints" of Baker's art, the "found materials, with pieces of wood in intriguing shapes, with rocks, with pieces of material culture left behind as if trash" (as Huth says) are both the media and very tropes of his language.

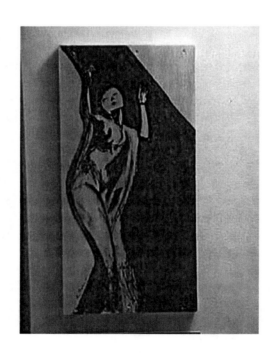

Chin Fay Ling

1 of 26 LIMITED EDITIONS signed and stamped by the author, *DE:SIRE IS*
is perhaps an even finer example of genre purity. This 12 page chapbook
published by The Knives Forks and Spoons Press (Newton-Le-Willows in
the UK) is unlike other Baker publications in that visuals (except for
the Chin Fay Ling dancing image on cover & personal stamp) don't appear
in the text, and the poems, untitled, printed in a light small serif
font (almost too wispy for the page), are set in a long vertical (top-
to-bottom) format, giving the act of reading a scroll-like feel. The
text is mostly left-justified with the exception of one smaller centered
piece that concludes the work's first section.

Ed's written in my copy, "What's a phantasy?" beside a self-portrait,
as if it were my own personal epigraph for the poetry ahead. Baker's
stamp is another curious way to introduce himself: perhaps a distinc-
tively Eastern take on the idea of authorial intention. The stamp (as
Baker's told me in email correspondence) is a chop carved/made by art-
ist Wing K. Leong in Portland, Oregon. Baker's Chinese name was given
to him in 1973 by Angela Jung Palandri, a leading teacher/scholar at
that time in Oriental Studies. " The name reads", as Baker says, " P'ei
Ai Te [that] translates to "Truth", "Love". Te is a "proper name" it is
Chinese characters not Korean.... though Kanji is Kanji all around."

The work could be the first time (with its absence of Baker *STONE GIRL*
visuals) the poet deals with textuality of the page. Some simple typo-
graphical manipulations are alone sufficient to homage his Chin Fay Ling
muse who is everywhere both inspiration and addressee. Textuality, yes,
but without the usual lyrical void of much experimental writing today.
DE:SIRE IS is a lyrical, narrative and minimalist work, seeming to uni-
fy a diversity of artistic modes in one dominant muse-figure; and spac-
ing, ellipses and capitalization are among many possible ways to create
verses that, far from problematizing, respectfully advance traditional
contexts. The effect is not one of hybridity but homogeneity :

desire is......

space everything
 to write into this

 is possibility as

BRUSH MIND

None of the cold, abstract verbal play for its own sake in which the
image is substituted for conceptual experimentation. Poetry in Baker's
hand (and poetry for him is a manual skill: artisanal, above all) is
never ever overlaid with standard language tricks (flarfs & "mash ups")
of contemporary Language poetics. Like all significant

cultural expression his work comprises of real materials, stone, paint, wood and language and takes its place in a literary continuum, as we've said, from Blake to Oppen to Corman to Hidetaka Ohno: the result of a disciplined and finely tuned Eastern minimalist style. The materials here are so attuned to the work's general design and impetus that each line (whatever its syntactical status) can be read individually as haiku or as haiku-lines within a larger narrative:

nurture

woman in the moist towards

who first speaks /embraces/ an erotic first

or speaks careful of what determines -care

politics become her
nature

Baker's poetry never interrogates its practice and language (as it is fashionable to do these days): it is BRUSH MIND at work, apt metaphor for the artistic impetus of most of his productions as well as a description of the freeing & nomadic style of work. What makes it contemporary (particularly if Baker seen as growing out of a 70s literary period) is its refusal to limit itself strictly to genre: arguably even Baker's minimalist poetry ("shorties" as he calls them), art, calligraphy, sculpture all derive from the same experimentalist period as L=A=N=G=U=A=G=E, the watershed New American Poets anthology, and perhaps even Smithson's sculptures. Baker can play with sentences & mine new semantical fields with the best of them, refusing to let his meanings mesh too easily with spacing, punctuation & lineation, choosing to create playful tensions instead: as in the line "around and dbls doubles back up on becoming poe m you set your/own/down/margins!"

But poetics won't intentionally try to undo poetry itself: there's too much respect for muse, materials and literary ground Baker walks on. There's too much literary sense here. When Baker dropped out of writing years ago it was to work as a builder, the years in between serving to solidify an already developing sense of working with real tools, & building real things. A sense of the materiality of work that isn't the vacuous intellectual game that post-avants like Ron Silliman have turned it into. The result is that Baker's is always an art-affirming " yes yes yes" to the prevailing no to voice and authorial design. Lovely poetic artifacts (like "glass bowl", "fish's home") can never be subordinated to triteness: the center does hold (even in the age of Language disanalogy & disfigurement):

```
edge
towards
sun
night
becomes
moon

's black

circumference

dresses up
center
```

Here the pains to "reach out" can result in contact with a poetry and language. If the page reads down the whole text (like a scroll), a definite sort of textual artifice, it's still the flowing or parted hair of Baker's muse we're actually envisaging. This is the personalized "phantasy" Baker's invited me to read.And (as I've said) if visuals don't appear in this work, his Chin Fay Ling muse still foregrounds the work, completing an otherwise colourless canvas:

```
                what color
                  demands
                  demands
                     she

                  punctuate
```

DE:SIRE IS and SG: Things Just Come Through must serve as introductions to the entire Stone Girl E-pic 1-5 presented here. Of a piece with both and yet always standing on its own, the work is what it is: artisanal and respectful. Baker's is poetry that doesn't call out for the usual protocols of Internet graphics, novelty and post-avant temperament. For how could a bare bones minimalist writing conjoined to art be anything but true to itself? If poetry is only a question of "media poetry born to pixels" (as Robert Kendall says), then it's a delicate house of cards, at best. But here is work that manages to retain all the elements and yet make contemporary Vispo look very empty, leaving the reader to look for the essentials of a more tradition-based visual poetry: a minimalism that matters and the most purely 'concrete' art that ever illustrated text. Writing that cuts to the bone, iconoclastic and original, and a 'Stone Girl' art sprung out of the lines themselves. Writing and art on Baker's terms.

Conrad DiDiodato

STONE GIRL E-Pic

Stone Girl E-Pic

Poems & Art

Ed Baker

Volume 1

Leafe Press

S

Stone
Girl

Walking
Mind

 in the
 ripples

 touching

Stone

 break
 a
 way
 rules

Girl

 Her
 scent
 in
 this

Stone Girl
pouting no
words

necessary

Stone
Girl
watching

also
full
moon

Stone
Girl:

"My
daughter

and
husband

need

 Me."

Walk
ing
Mind:

"Yes,
 Dear."

Full
Moon

just
a
nother

perfect
enso

Stone
Girl
on
the
surface

rad
i
a
ting

This
dialogue
between

us / Stone
Girl
get ting

Her
R O C K S
off

Kokoroaruite

very
good
at
keeping

mouth

shut !

```
same
thing
again

a
gain

kiss
Stone

all
o
v
e
r
Girl

        Walking
        faster
        Mind
```

who
is
it

(anyway)

can
win
and

what
is

prize

on'na kokoro
 no ko a
 iwa ruite kissing Kiss
 ing

(translation: Stone Girl Walking Mind Kissing Kiss ing)

```
          Stone
          Girl

           in
           Her
          Garden

           pee
           ing
           on

           leg
```

```
       StoneMindWalkingGirl

             every
             metaphor

             has

             two images

             - Dig It !
```

```
          Stone Girl
            pulling
              me

                     one
                     way

               her   hair
```

```
Stone
Girl
pull

ing
Me

d
o
w

n
          s l o w
```

tracks
-back
is
poem

leads
me
to

Her

sudden war
mth melting

insides

phone, RING / Mailynne Tu / reading Mom

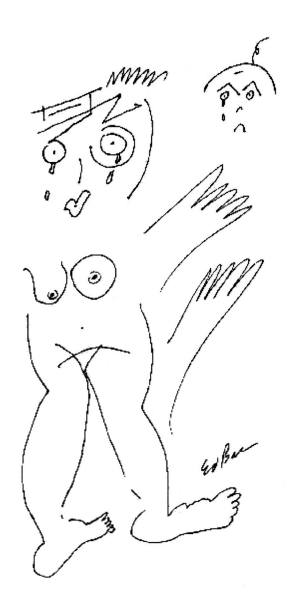

watching
Stone Girl
watching

motion
picture

teary
-eyed

CryBabies

J.M.'s

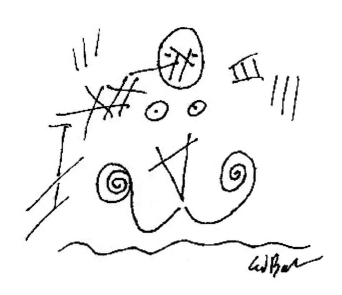

Stone
Girl
mak

ing
Me
a

bet
ter
lover

not
possible
keeping

tongue
in
mouth

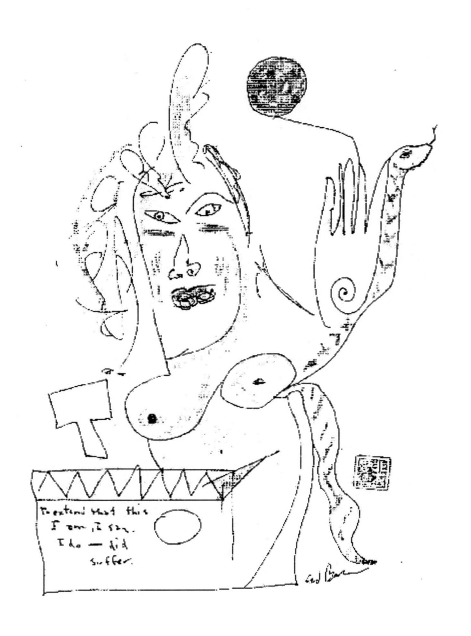

 noh
 ideas
 but

 in
 Things

 doesn't mean
 no
 Ideas

 Walking Mind
 lost
 in

 Her

 Tawny

Stone
Girl

suddenly
struck
by
a

point
of
view

full moon
beautiful
She-smile

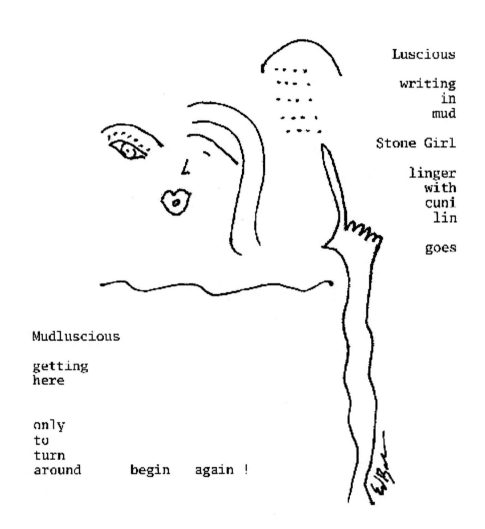

Luscious

writing
in
mud

Stone Girl

linger
with
cuni
lin

goes

Mudluscious

getting
here

only
to
turn
around begin again !

Saying

"You are pretty!" only starts an arguement

Stone
Girl

Walking
Mind

in
love
with

Love

on
the
way
baby

chooses

materpater

 want
 is

 to
 be

 butterflies'
 kissing
 eyelashtoeyelash

 -P.W.'s

Tshoo !

Tshoo !

al
so

ma
ke
s

it
so

devo
lution
in
this

touching

Feather Rock

Stone Girl

on
Cave

walls

snow blankets
Stone Girl

Walking Mind
settling
 in

 only
 Subject

 seeing
 noh
 Object

 Stone Girl

 nay
 kid

Th
e
ob
je
ct

I'
ve

wher
e ev
er I
go t

here
S he

is !

full
moon

delv
-ing

into
your

true

color

 color
 of
 stone

 Girl

 Doan ing

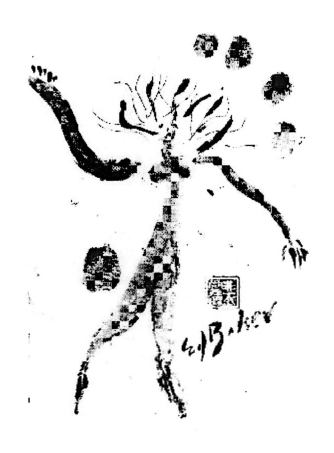

yet,
 nothing
 moves
 me
 this

 alone

turns
her
head

revealing

fullpout-
 purple
 lips

She

 f
 l
 i
 p
 s

T

began
in
water

in
to
Stone

Girl
Walking
Mind

 a
 fecundity !

warm shower

playing
in her
hair

Stone Girl in wet dress going down Vestry St.

full moon
wild orchid

 young
 sun

 Many
 Stone

 Girls

 Walki
 ng M
 ind's

 heart
 and
 soul

Stone
Girl
is

aphanite

 too
 fine
 to
 see

assuaged

 -J.S.'s

eyes'
happiness
mind
to
see
you
with

cent
ral
fig
ure
what
is
left
sus
tain
s

Ed Baker '05

Summer
in her
hair
-yellow

ed B____ '05

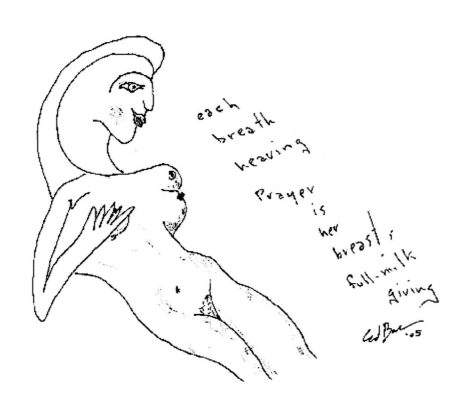

each
breath
heaving

Prayer
is
her
breast;
full-milk
giving

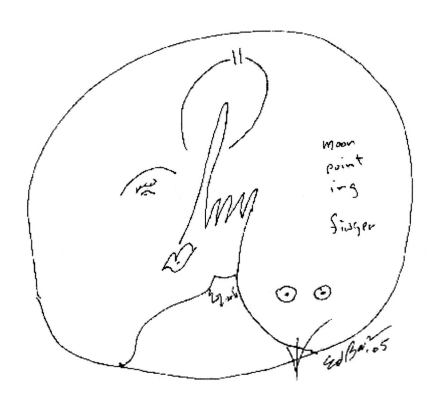

Moon
point
ing
finger

come up: Come-up-Sun-Mother-
Stone-Girl is mountain

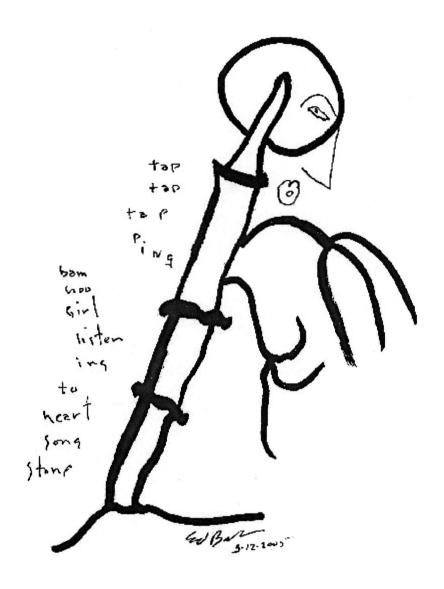

tap
tap
ta p
p.
i n g

bam
boo
Girl
listen
ing
to
heart
song
Stone

through snow
pussy-footin'
olde cat

stone
girl
alone
dancing

far away flute
sounds

watching
thinking
watching
Blind Girl

—Ruddy Quail's Dove

Ed Bar '05

full baNANA
dreaming
Sour Cream

Moonless
Full
drop
p
i
n
g

No
thing

happens

for

No

reason

embraces

nō
punctu
ation

but

this

GwB. '05

full moon
full lips
full

full

So many
in
owe pond

-riv.it!

Ed Ba

Stone
Girl
brush
has
walking
mind
its'
own

warm shower

playing
in her
hair

52

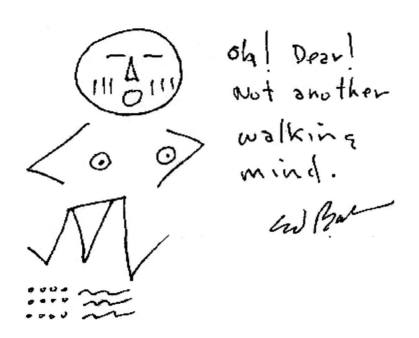

Oh! Dear!
Not another
walking
mind.

So. . . .
maybe you think
walking mind
should drop
walking

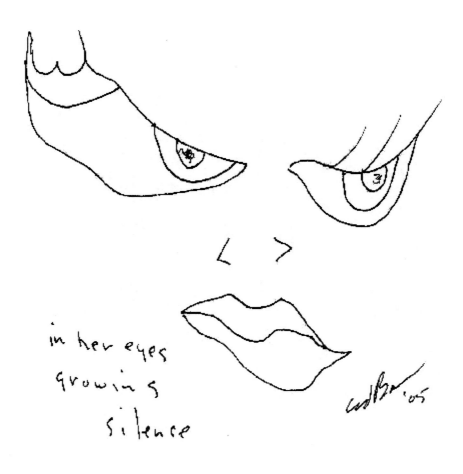

in her eyes
growing
silence

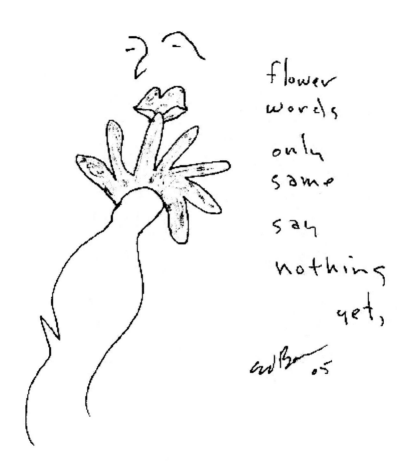

flower
words
only
same
say
nothing
yet,

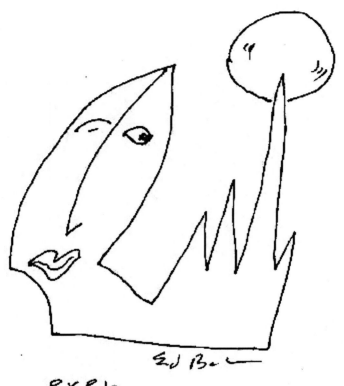

even
this
point
pointless

CHUNG fu: no words necessary
— Joan-Frang's

Purdie
make
take
stone
Girl
yama
to
yoko
mama
each
kiss
first
time
In her
TRUTH
in to
her
OH! Baby...
CHUNG FU
above
&
below

(open)

not
one
line
changing

58

Stone Girl E-Pic

O

"What attracts me in such a manner of seeing is that,
as far as the eye can see, it recreates desire."

André Breton 'Mad Love'

in this construct sudden Dawn springs from pool
-perfect
wet lipped purple mousemouth takes and gives

walks his mind to wake waves
back and forth laps see glides
her every other

Jump is high Dance is Madly
just as it is next moment not
certain Get lost in it !

Walking Mind-speaks

Stone Girl-'ears

 all-so in mouth
wagging tongue's

one kiss embracing all of this clearly walking towards

Stupid! Stupid! Stupid! You,
Mr. Walking Mind, never,
ever go and just ask:
 "Stone Girl marry ?"

slip's
through

and
fingers

tawny
sand

coy:

"Do you
 think

 that I
 am

 cute?"

Yes. Yes. Not same when One Girl says YES ! Ye
s. Y e s s s s s s ! Now and Then is Stay-awake

Mind leap is into SPLASH as same dive to see
under water her go by

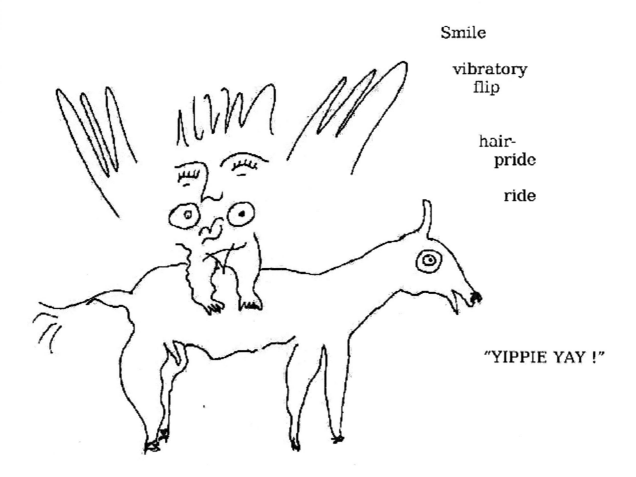

Smile

vibratory
flip

hair-
pride

ride

"YIPPIE YAY !"

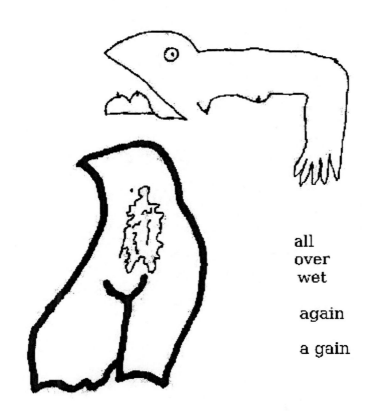

all
over
wet

again

a gain

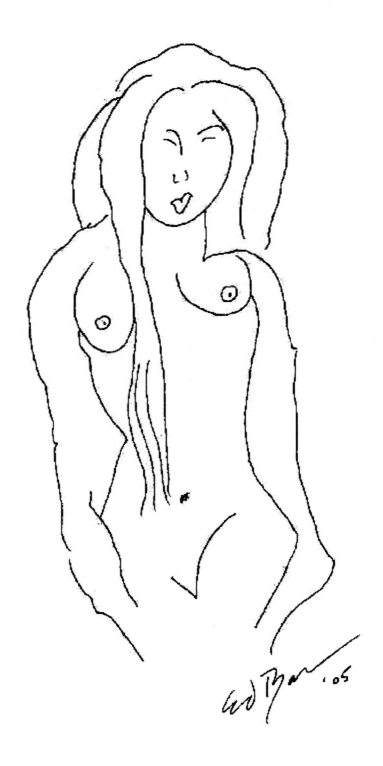

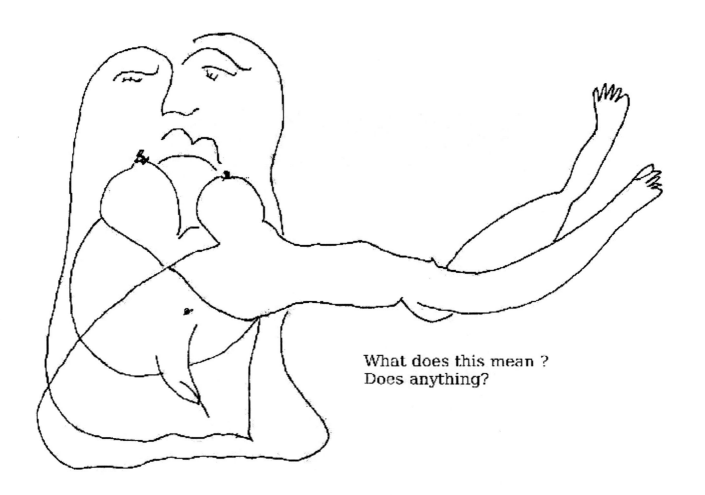

What does this mean ?
Does anything?

SUPPLICATION

She lays just here
where I not live while
in her eyes a multi

plicity stoneificate and grown hard
soft lips and tiny purple breasts
desire's to
kis sssssssssssssssssssssssssssssss !

Star Girl blurring vision

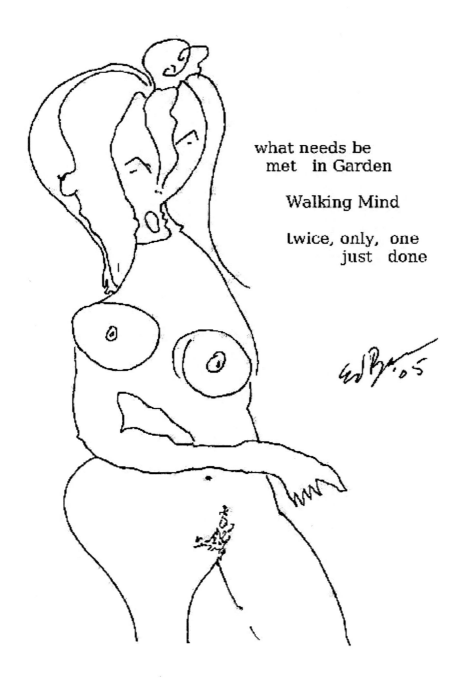

what needs be
met in Garden

Walking Mind

twice, only, one
just done

not using words/hard/habit//to/break

after Picasso:
now that your Crazy Love is above ground
under cover of night
 do-able

possibilities every
 thing
 else

 transpires

deep
down
flap

goes
sudden

shake

"All YOU THINK
about is sex !"

...and the crunch
in the bite of a
Gala

just
a
nother

perfect
enso

N

```
 yet
no
thing
moves
me
this
alone

Stone
Girl
turns
her
head

re:veal
is
full-pout
-purple
lips

        at
        wall
        we

f
l
i
p
```

began
in
water
Walking
Mind

Stone
Girl

a
fecundity

need's
demand

no
words

necessary

 use
 of
 numbers
just
to track

```
another point
        point
        -less

:should  'thing'

 be
 formatted
 to
 fit | size
 of

 insated ?
```

AH,

Walking
Mind
not
appearances
cluttering

have not shown
Stone Girl
what
" no"
is

haves
or
wants
to
give

Walking
Mind
such
luck

Born
Snow
here

buddha
in
pile
of
waiting

I
will
just

ask
her

have
sown
such
seed

Joy
is

Stone
Girl

guide

or,
else
where
revealed

```
all
so
needs'
demand
repetition

:
in
many
ways

in
Mind
Girl
Walk
's

a
woman
```

Walking Mind could be lost if her
 marriage fails

No
ideas
does
not
mean

Stone
Girl
says
it
so

Kiss !
is
absolute

It
isn't

only
hues
&
eyes

colors
Mind

Under
stand
ing
makes

making
this

a
communication

Practice.
Practice.
Practice.

Walking
Mind

crazy
only
feelings

come
&
go

"What do you
want?"

easy
question
she

asks

Stone Girl
unlike
me

knows
fear

answers

that
which
gives
&
takes

simultaneously

Ai!

did
tran
s
mit

as
an

'attachment'

d
o
e
s

a
n
y

thing

now
we
'll
'really'
try

get

d
o
w
n

& open

Eyes
happiness
Mind
to
see
you

come
is
up

comes-up
Sun
Young

Mother

Stone
Girl
sing
is
mountain

Walking
Mind
keeps
pop

center
fissure
Stone
broken /
half

Girl
is
left
two
children

sustain
is
her
knowing

Mind
Walks
with
foot
in
mouth

every
thing
Walking

Yet,
she
makes

Mind
a
better

thinker

not
so
much
worry
ing
a bout

nor
Anger
is

Open
ing

s l o w l y

count
less
ways

Stone
manifest s

a
woman

like
this
that
which
is

is
adequate

Walking
Mind

loves
the

Slimy

Stone girl
in
Forsythia
peeing

ain't
goin
in
to
no
Stone

with
out

permission

any
way
works
as
well
as

walking

FEATHER ROCK RICE MOTHER

```
                              tap
                              tap

           t
               a
                   p
                       p
                       i
                       n
bam
boo
Girl

listen
heart-song

Sun
Young

some
voice !
```

when
visit
arranged

put
arms
'round
downward
moves
to
Kiss !

Stone
Girl

in an
Easterly
fashion

She
bends
to
please

AN NEZZEONITY STONE GIRL POEM

purdah

makes
taking
her
out
in
public

Yama
hama
to
Yoko

Mama

not
possible

each
kiss
in
her
first
scream

In her

"OH, BABY!"

 Chung Fu

 above

 below

(open)

not
one
line

changing

 Oh, her laughter !

Stone
Girl

not
thinking

droping
Walking

Mind
all

together
and
could

also
take

What
little
can
be
done

self
swim
better

flip

and
push
off
wall

some
fish
swim
with
dropped

Mind

Without
Mind
Stone

dives
into
murky
pond

sinks
to
bottom

so
many
frogs
in
one

pool

croaking

```
Wet
Walking
Girl

an
Aphanite

          too
          fine
          to
see
with

only

eyes

Assuaged !

Sun Suddenly Aroused.

    H E Y   !
```

what
if
in
leaping

suddenly
She
hit
head
on
rock !

cun
cus
s
ing
love

 ?

 Oh-Access
Stone
in
Garden

also
Mother

Prac
tice
too

keep
ing
mouth

shut

tongue
in
only

this

 Two
minds
walk
in
garden

flower
so up
 see
 ing
 her

suddenly

Spontaneously

 all
 of
 Doan-Trang

in cold water

without a doubt
swim is faster

one
day
we
will
all
suffer

 -just
 by
 drop

 drop
 ping

just
here !

W O W !

jump
is
in

Stone
sinking
Mind
swimming

 " You did good"

"Do You think I'm pretty?"

think
ing
with
only

feet

go
see
Girl

Purple
lips'

smile
on

grey
head
hair
copper
tone

in
pool
keeps
up
 with half his years

Kanji
curvings'
delve
in to

Stone
Girl
strokings

brush
as
what
us

being

seen
and
said

Did
Walking mind
say
 'That' !

Mind
swims
by
makes
waves
toward
Dawn

says:

"Glad
I'm
Here
&
There"

 -After All One Wave
 Stone Girl smiles and swims

key to Mind

keeping
finger
out
of
eye

send
ing
Stone
Girl

first

a
"love letter"

Stone Dawn Sun Young Full Moon scents on
note just here and her participation

here
are
both

attached

This
there
is
a
waiting
next

irruption !

 her line-form
 mounted on horse
 (of course, in my
eyes an innocence)

Waves
arms
hands
lips
hair

all
smile
vibrat
ing

flips
black
hair

 goes fast a woman

Practicing
word
good
thing

Walk
Away
Mind

Did You get my messages ?

not
much
covering
her

top
&
bottom
matching

bikini
string

Walking
waking
Mind
see
Stone
Girl

happy
eyes
to
see
and
meet

Ai !

This immensity

Why look
when one
is seeing

Sun
Dawn
in
eyes

wide
open
in

laughter

Community Swim Center

center
of
pool

two
stop
same
moment
speaking

Everyone
watching
what
is
being
said

chatter-touch
plumb-lips'

Kiss !

irreducible

go
ing
far
ther

to
get
clo
ser

sudden
s

p

l
a

s
h

lots
of
water
a
round
one

kiss

if
careful
give
this
what
else
is
to
give
or
given

only
draw
the
shape
of
each
other

Done Dawn
Sun Young
each part
its' own

Walking Mind TO SPEAK. Stone Girl TO SAY.

Two
 mouths
 wagging

 tongues

 :

STONE GIRL E-PIC

Volume 1

E & G. I. R. L.

"Thus we learn that the stone is the Goddess herself"

-Marija Gimbutas' "The Language of the Goddess"

E

Eros
moves
mind
walk
to
love
Rock's
lesson

wJB~'06

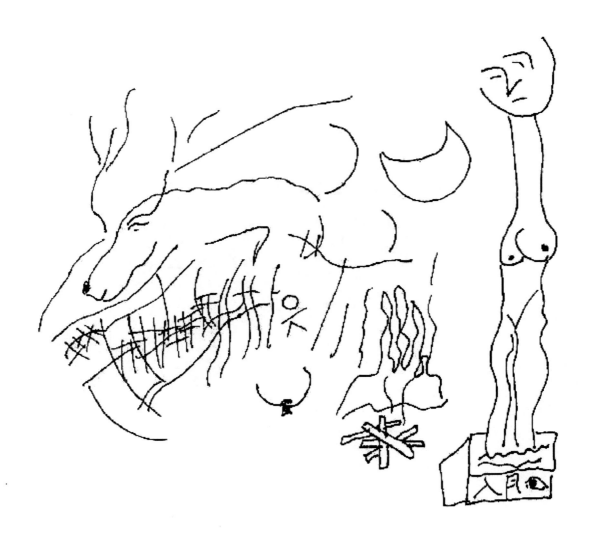

in this light
"fantastic figures"
fire scapes

She calls at
Dawn
in The 5 a.m.

who
is
waiting?

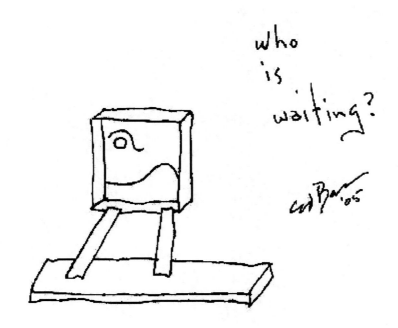

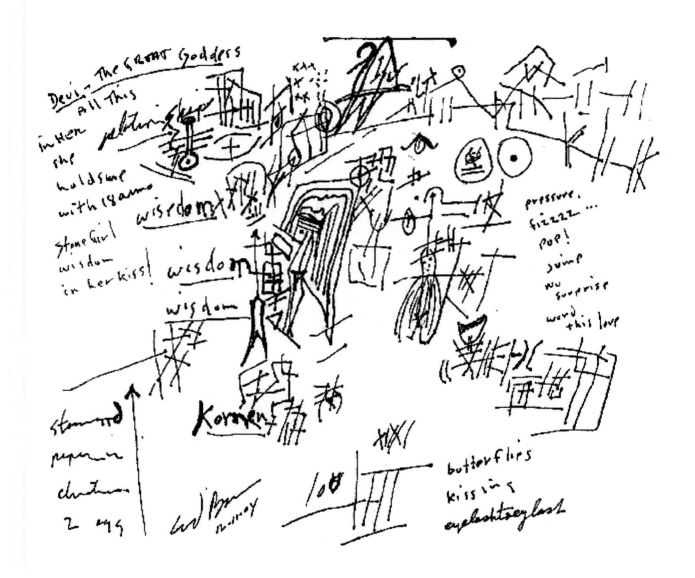

Devi - The GREAT Goddess

All This

in Her she holds... with 18 arms

StoneGirl wisdom in her kiss! wisdom wisdom wisdom

Koronen

pressure. fizzzz... POP! jump no surprise word this love

butterflies kissing eyelashtoeylash

131

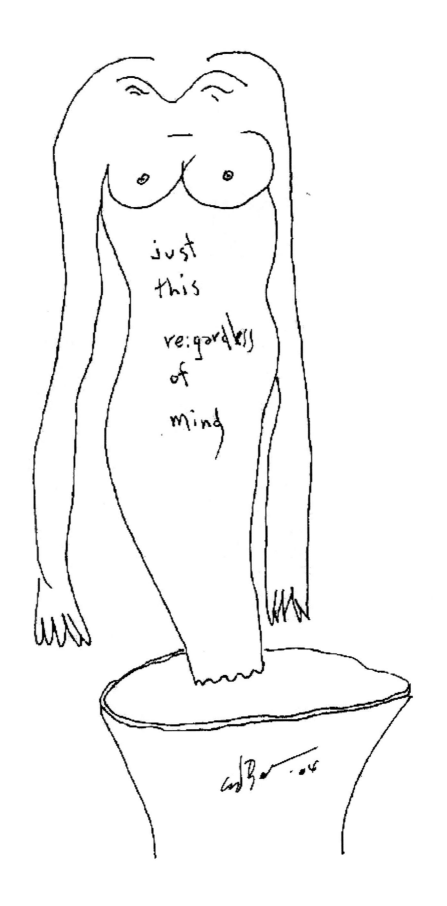

133

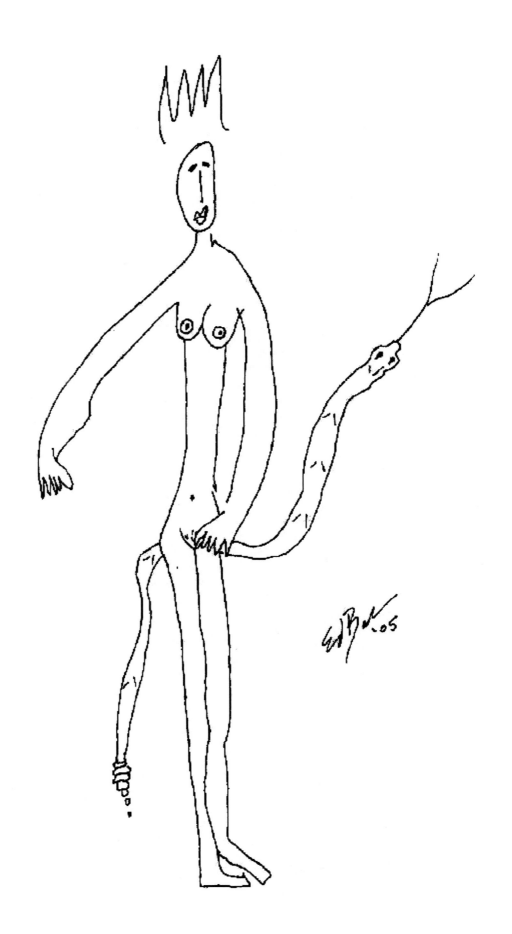

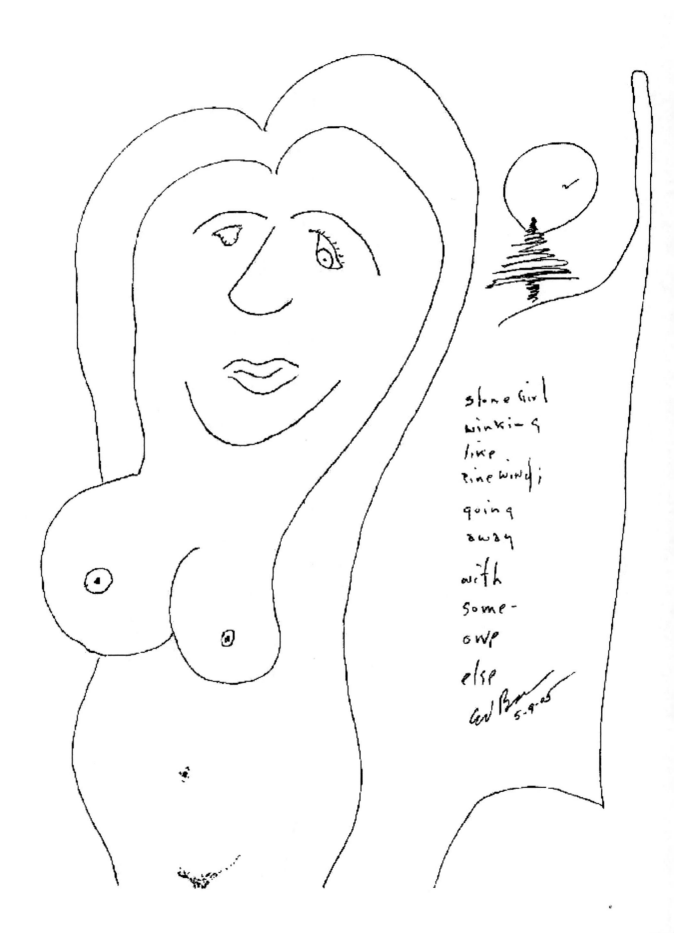

stone Girl
winking
like
pine winding
going
away
with
some-
one
else
GN Baw 5-9-05

135

;
knock

on

Rock.

open
with
out

hesitation.

walk stump ing / its
ing girl giv equan
mind tak ing imity

136

Crook in
mountain

risen
to this
occasion

touch
is
big
with
every
thing
else
for

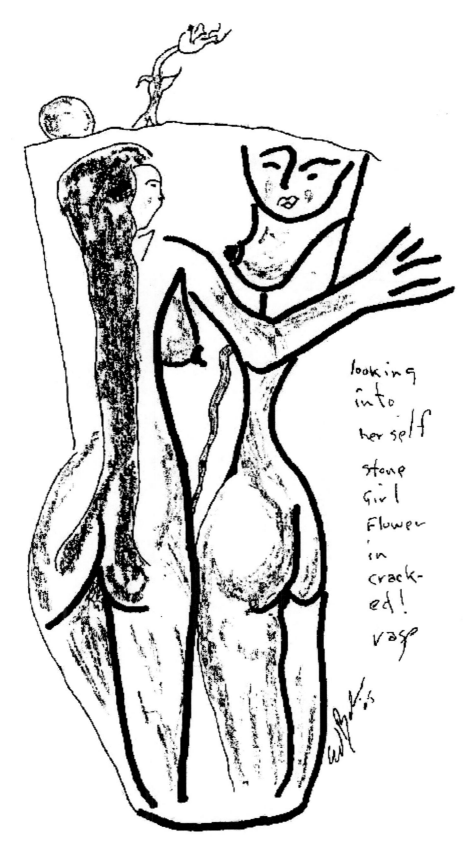

looking
into
her self

stone
Girl
Flower
in
crack-
ed!
vase

— after P. Picasso —

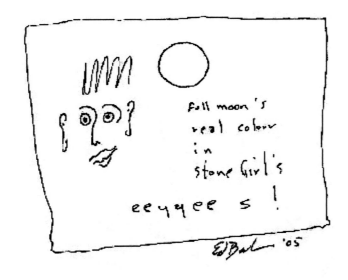

full moon's
real colour
in
stone Girl's

eeyyee s !

EBal '05

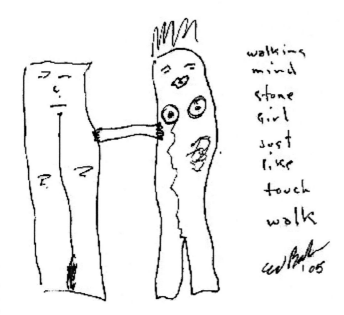

walking
mind
stone
Girl
Just
like
touch
walk

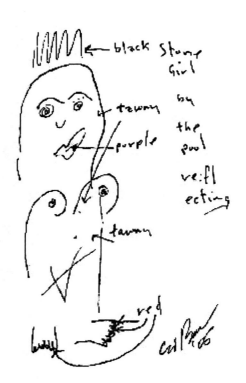

black Stone
Girl
by
the
pool
reflecting

tawny

purple

tawny

red

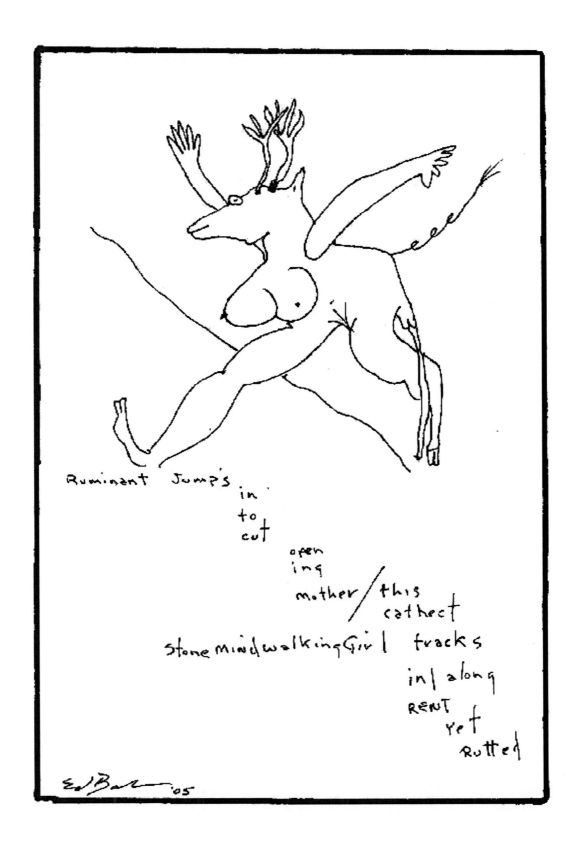

Ruminant Jump's
in
to
cut
open
ing
mother/this
cathect
Stone Mind walking Girl tracks
in|along
RENT
yet
Rutted

Stone Girl Epic
Part I
— finis

In

stone flower

Girl
opens
w

responsibility

143

Seeing
with
own
eye
in
her
Garden
all
aflutter

Ai!

layering
equally
split
shale

Walkin'
Mind
Suddenly
double vision
How Pleasant!

one
wave
seeing
Holding
Stone Girl
intentionally

Doan-trang
mind
in
the
open
makes
it
So

Sudden View Awakening

150

within & without eyes seeing

moonless Sun Young Song And I

StoNe
GiRL
dances
while
far
away

Mind
seeing
Sounds

PRACTICIng
practicing
in
my
mind
Girl
lost

bamboo playing with sudden breeze

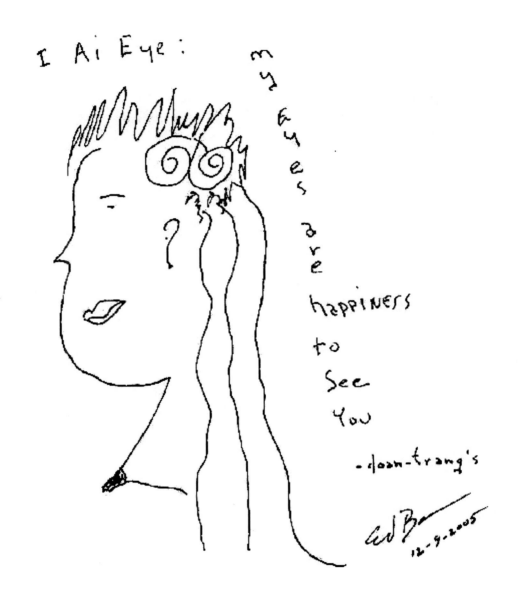

I Ai Eye: my eyes are happiness to see you
— doan-trang's

160

"Just as the waters enter the ocean, full and of unmoving ground, so all desires enter him who attains peace, but not the desirer of desire." - Bhagavad-Gita (2.70)

StoneGirl Epic Vol. Two

Ed Baker

whirl...

sarsen___!

wherever

wE turn

our

Face

re:flecting

ErB '06

wom

Mois

Girl-A-woMAn

IS

love is one
true
religion

Stone Song:
madrigal solitude

.trang

mailynne tu

Ed B 06

ebb & flow
more of completes
less said/done
Love is····

wB····06

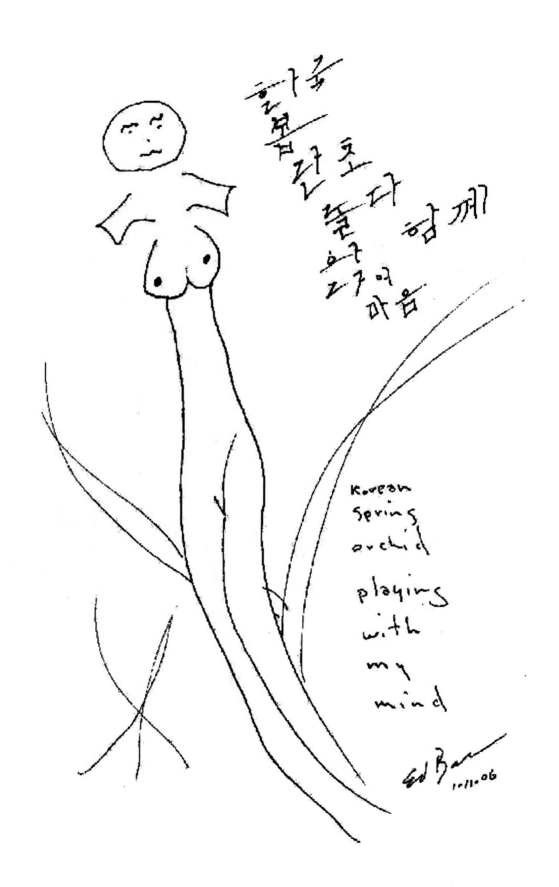

한을
봄난초
달과 함께
놀다 한의
마음

Korean
Spring
orchid

playing

with

my

mind

Ed Baker 10·11·06

f
r
s
r
o
m
l o
w Q
i m
d
f c r d d
g h o w e
v
the night away

170

Pastiche

SUDDENly a frog jumps in
OH! The Slimy.
TWANG-KISS-PURPLE
liPs
:
— —/——/——//——/——/—

(stone-Girl) is Fêng/Abundance

is

[Fullness]

is

wide-eyed open takes & gives

EnTiRely

companion

Stone /mind :

CoNcAtenat E

EB.

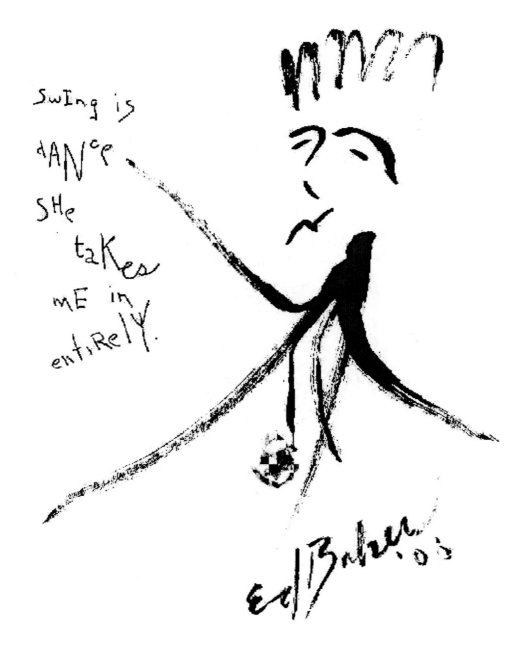

swIng is
dANce.
SHe
taKes
mE in
entiRely.

Ed Baker '03

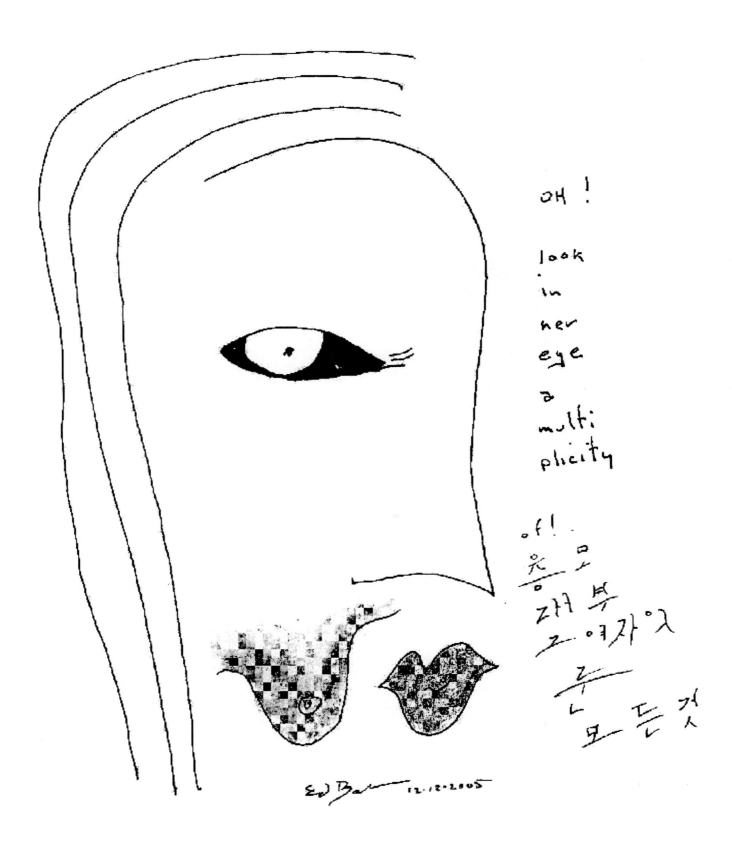

OH !

look
in
her
eye
a
multi
plicity

of !
옷 모
래 부
그 여자 ²
돈
모든 것

176

Stone Girl
Initiating
a Conversation

7-21-05

stand alone
GIRL
OoLALA!

rrriiInnGgg!

BeLL-ME
InTo
SoUnd

oo BoY!

many 만 myriad

*# feelings
Nu-ggin 느낌

a-vŭm-da-un 아름다운 ——————→ beautiful
*
←————————————
i gose 이곳에 *
here, in THIS place

o-da 오다 ——————————→ c°mmIⁿg

182

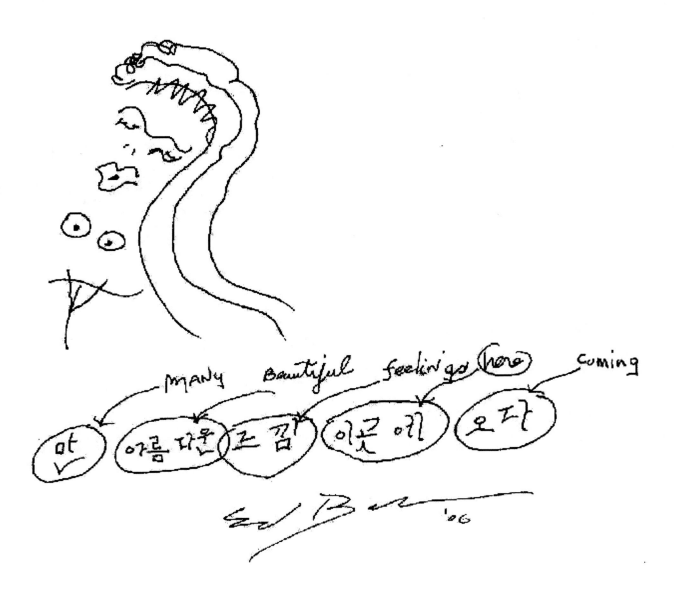

MANY Bautiful feelings (here) cuming

얌 아름다운 느낌 이곳에 오자

Ed B '06

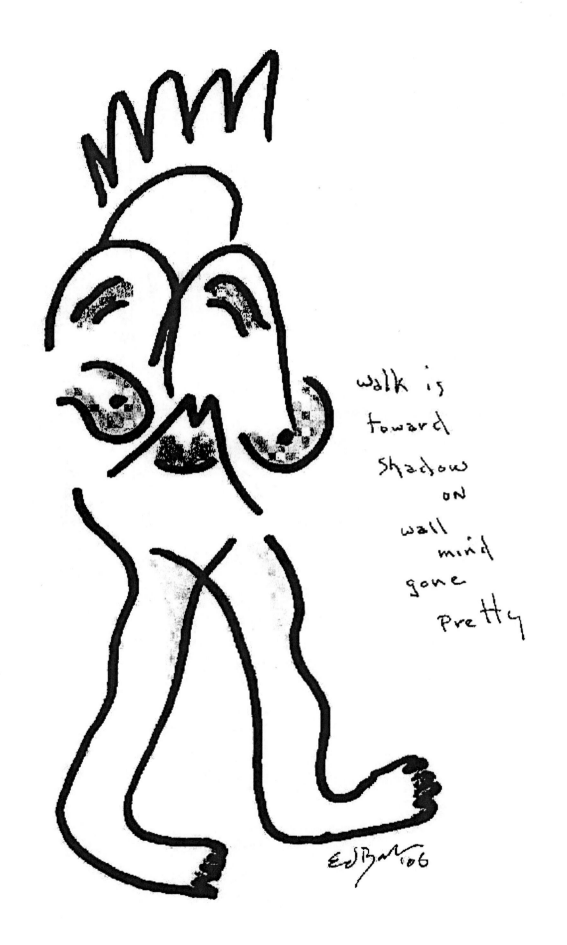

walk is
toward
Shadow
on
wall
mind
gone
pretty

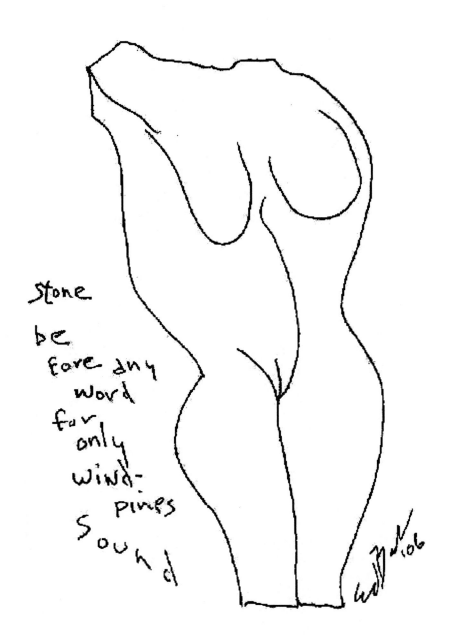

stone
be
fore any
word
for
only
wind-
pipes
Sound

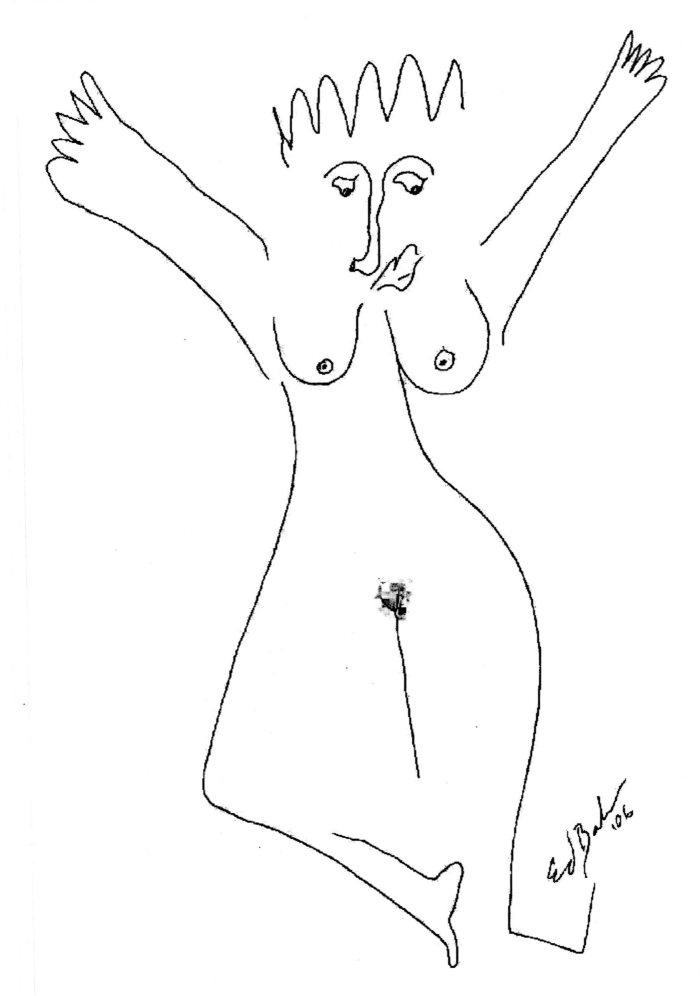

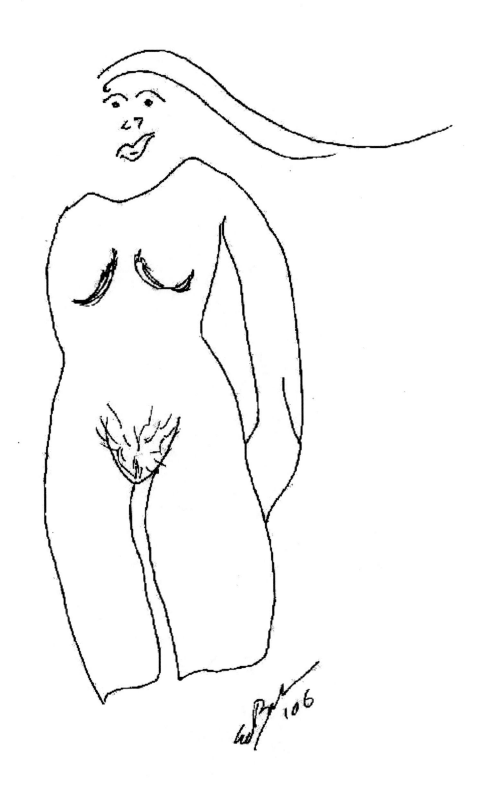

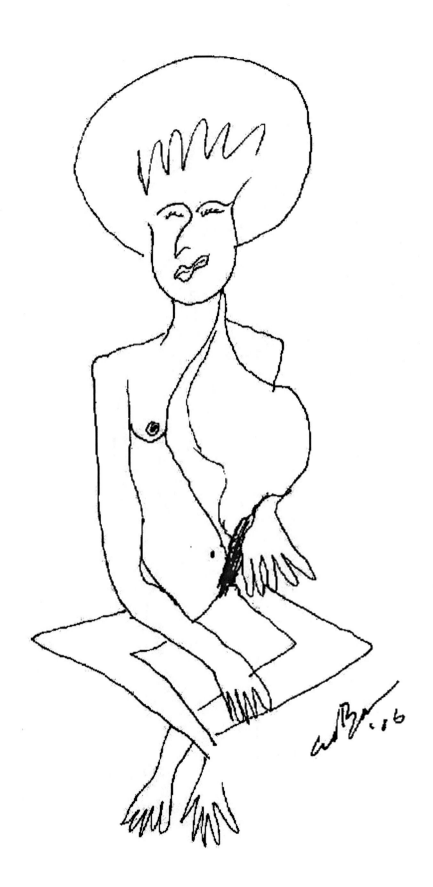

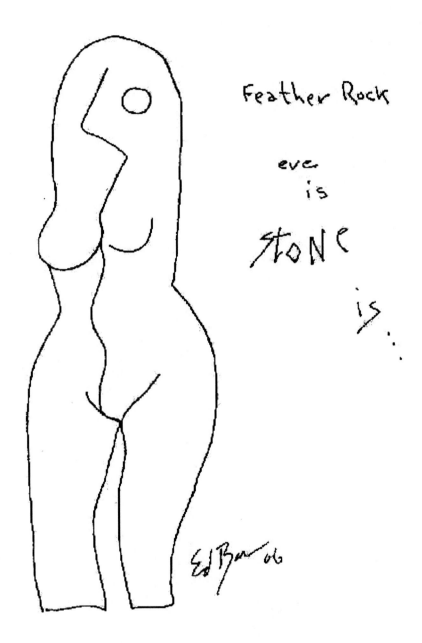

Feather Rock

eve
is
STONE

is ..

Ed Bar 06

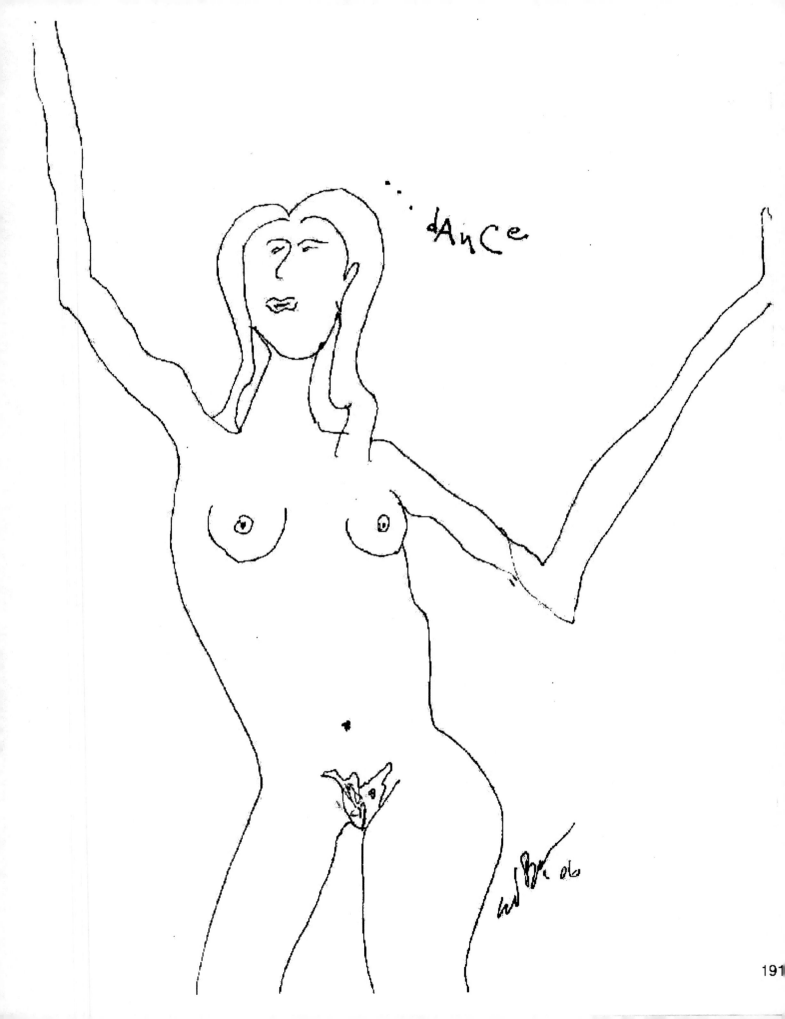

dAnce

from her(e)
th rest
is up to
us

in her

movement

everything

19

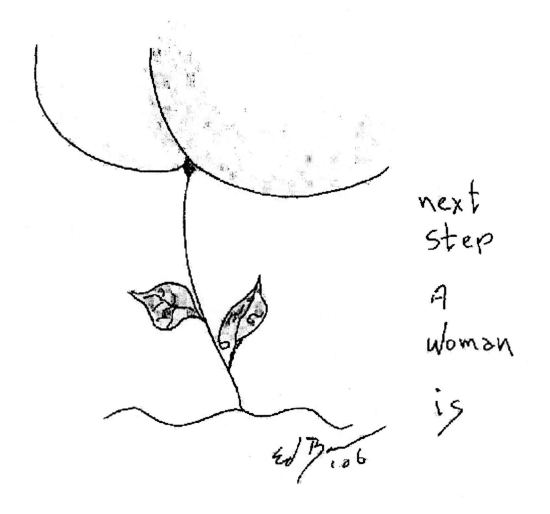

next
step
A
woman

is

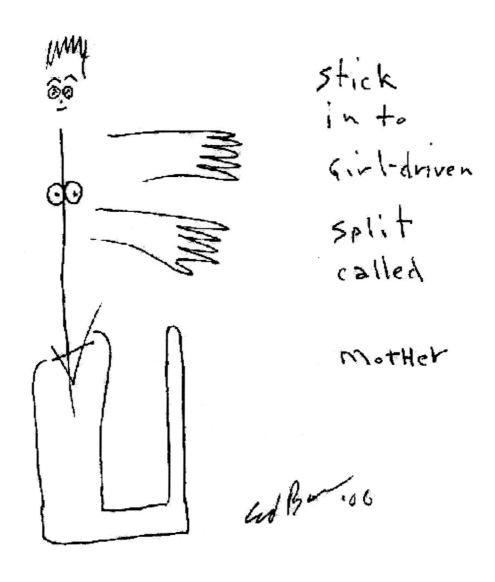

stick
in to
Girl-driven
split
called

mother

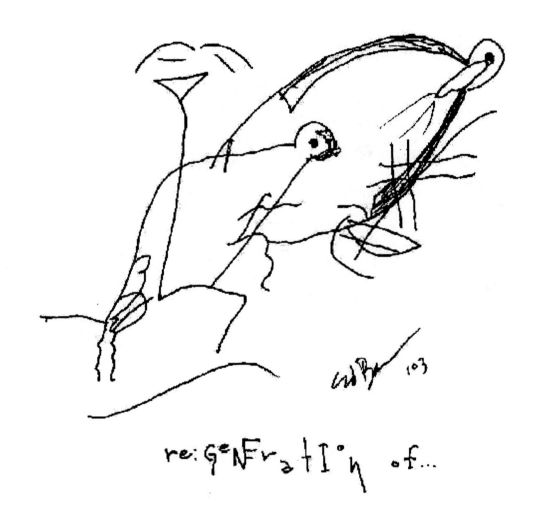

re:geNEr₃tI°η of...

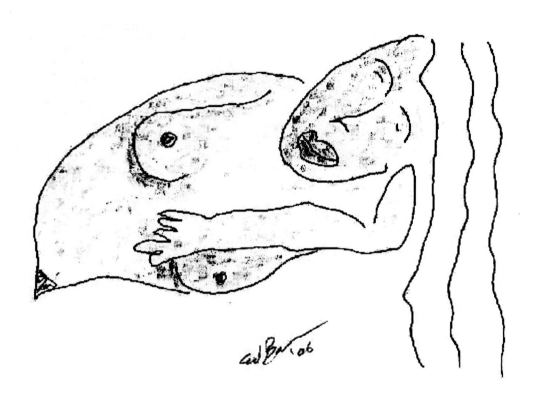

Stone Girl E-pic Vol. 3

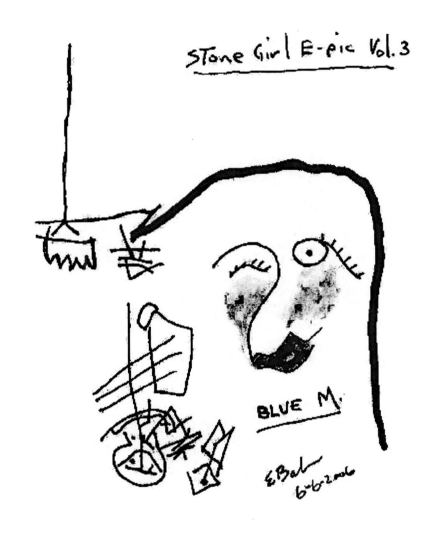

BLUE M.

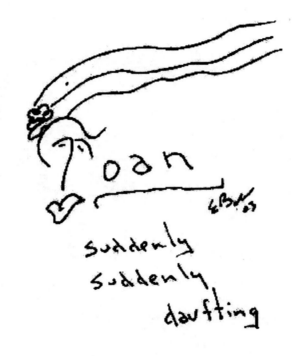

suddenly
suddenly
daufting

201

every needs
 sun
 to be
 just don't
 look at it
directly
 EBrom

wind / bending

204

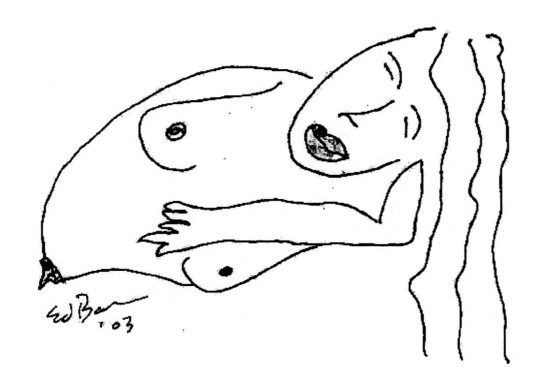

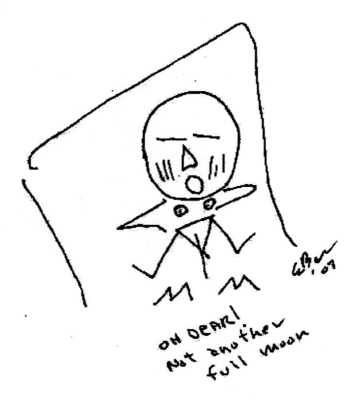

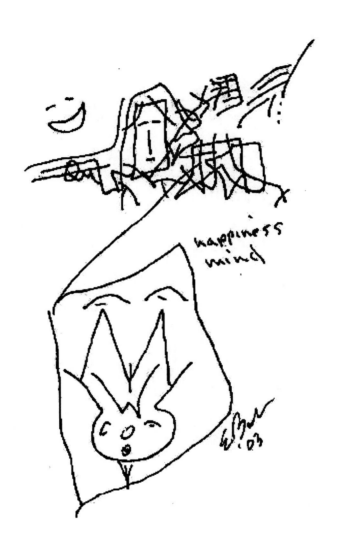

happiness
mind

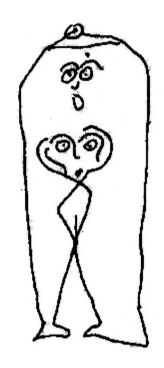

Do you think we fit?

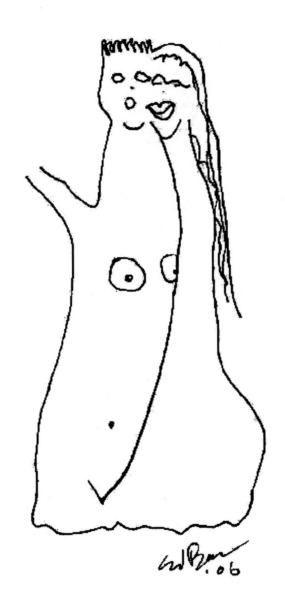

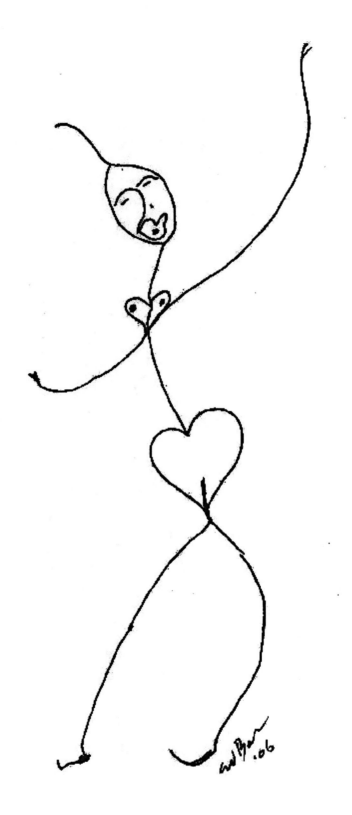

Stone Girl

Epic

Volume 4

Ed B

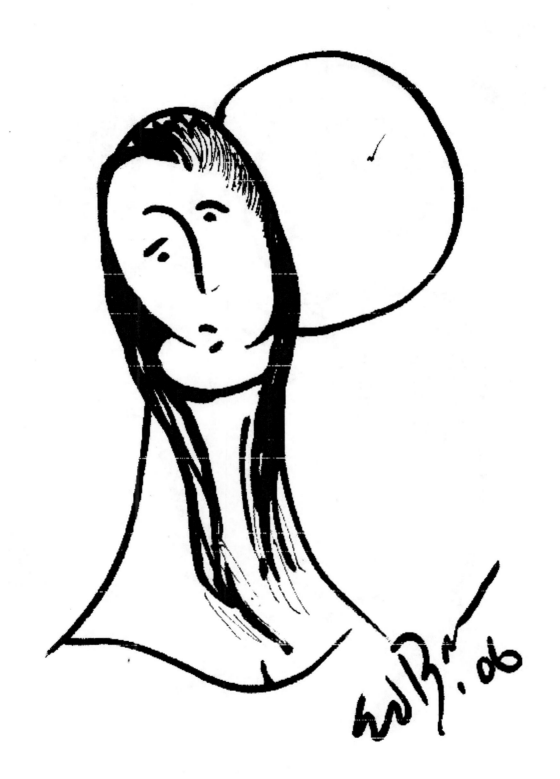

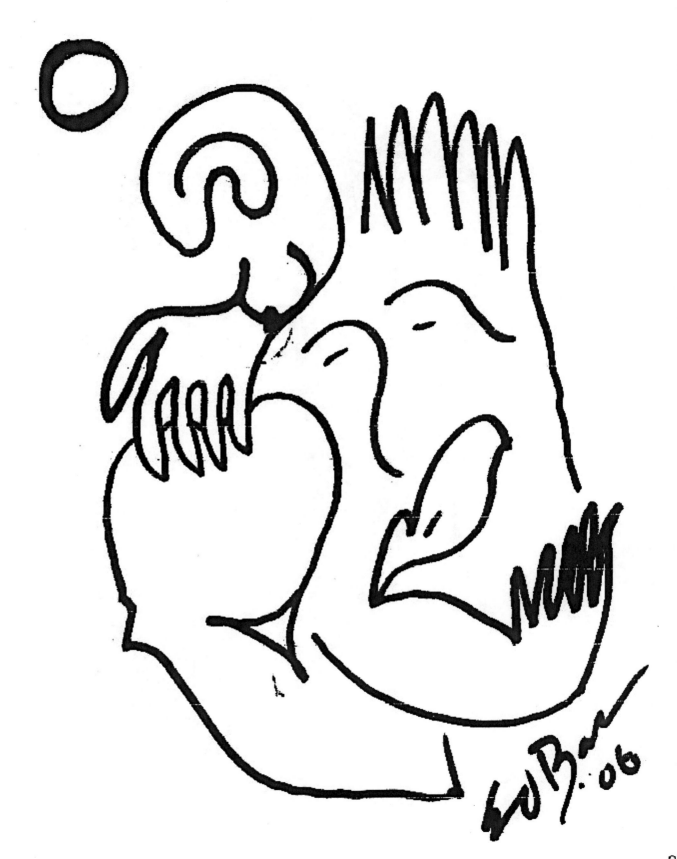

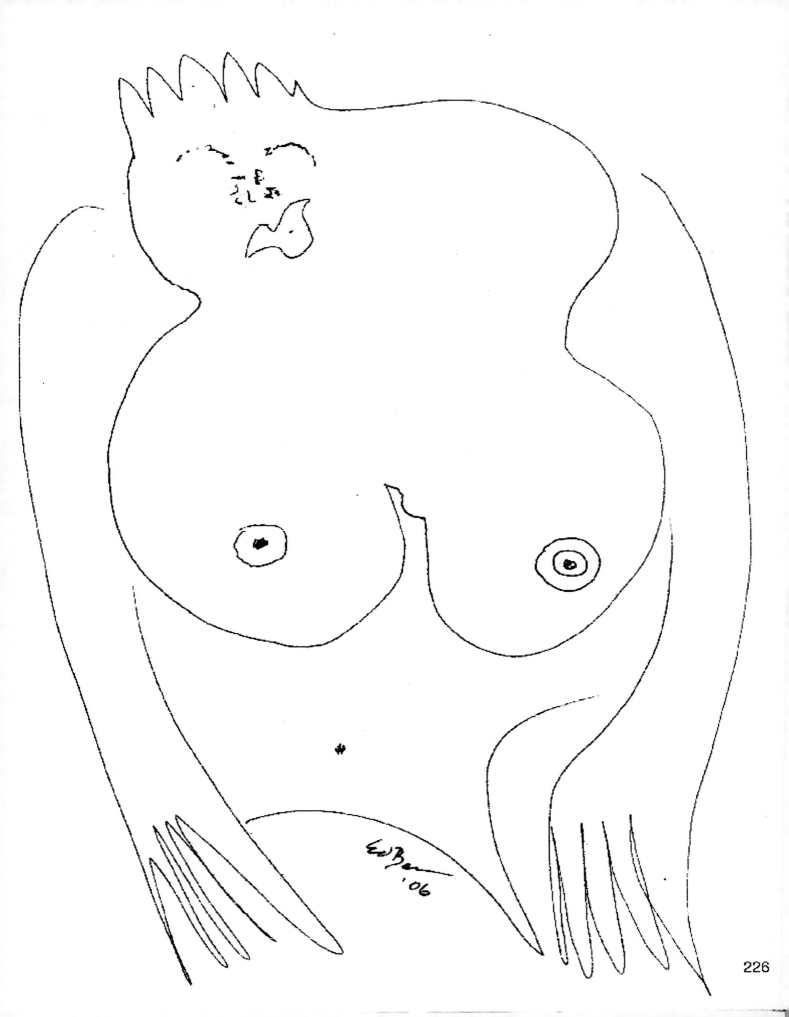

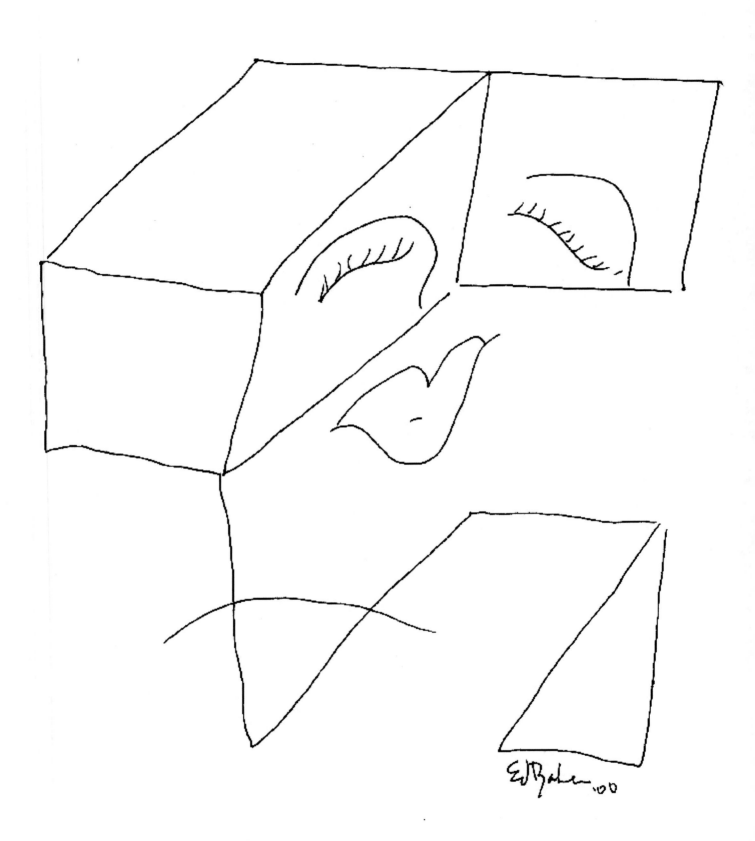

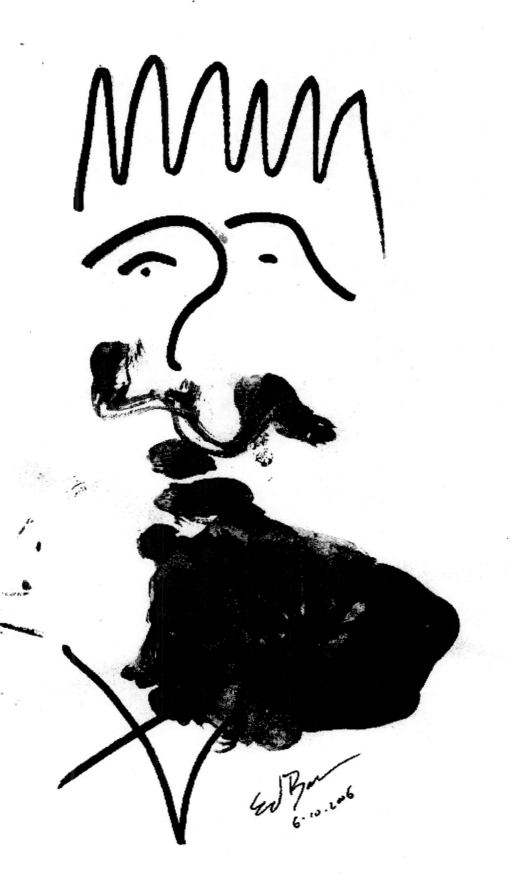

230

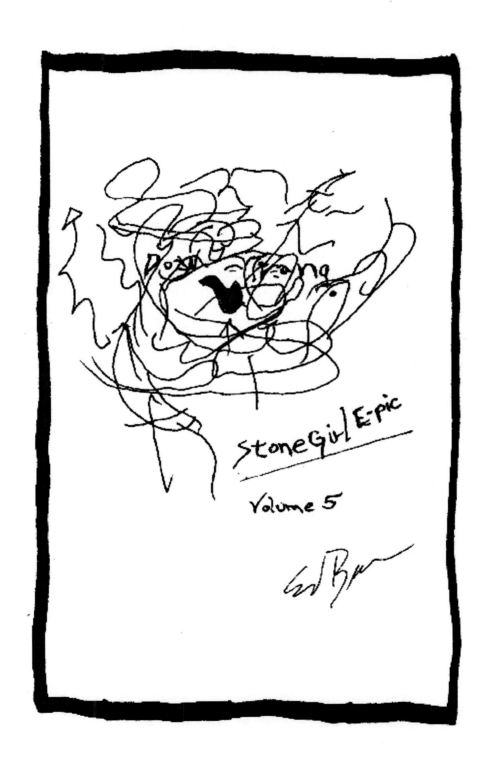

StoneGirl Epic

Volume 5

 go
 into
 stone girl
 walking mind
 begin with

 nothing written can say

 some fine things punctuates

 a u t h e n t i c i t y

 . .
 . .
 . .

 v

 entering opens entirety

 girl a mother gives

 nourishment

 just within

these possibilities

stand is in front of cave wall

d a w n

scant cover what little there

reveals

where and when and what and who makes it so

more than questions in of necessity

do not sell another right of way s t r i k e transaction

before baby is cooked or eaten

want need longing

desires drive

to have stone purple lips

sound of comfort

being

embracing fire

thanks to her fore sight

cave wall writing instructions
same way walking is in spite
of tongue in mouth and
keeping penis in

suppose that it is the first time wearing ring

go down
just ask
repeat

i thee wed

here is y e s

life is in the
open

leg s moisture signal s what is ready

snow in cave temple s
tracks inward

live
walk
swing
dance
round
fire
heart

soul
mind

green
light

stone

cracked

perfect
flaw
wall art
marks
clearly

emptiness
next to hot
makes home
while sleep deep
in dreams
and metaphors

mark on rock
symbols
abundance

 in this light
 horse
 very near

where h a g o s rise to mount

 how d
 i
 d

 mind know how to connect and
 was it they who worked together mated

 gone

 mailynne tu
 tiny tawny
 cream comes

 nurse is with opened eyes wide range
 to gather food make is circle 20,000
 years out production mother given

 everything is in the open formula

 ex
 perience
 what
 remembered

 copies
 passed
 down

 alone stone
 walk is with
 and the others

whew

work is process being

on
ly
wh
at
first
can
say

be
w
 r
 i
 t
 t
 e
 n

s t o n e g i r l

dezzzzzzzezzzzzzz zzzzzz zzzzzzzzzzzz

beneath cover cold turned purple shivers

girl
one
mind

one

baby

everything else following
formula

one sinusoidal wave wave s back
z(x,t) = a sin(kx wt)

i

full
em
pty

sign symbol

moon

knows her periods

wave motion in time the quantity k

2 pi

divided by periods

its one wave in space

kanji man

upright

round dancing travel flickers

hearth is center

through stone talk rock mouth
speak is magic stacked in mind

walking cairns mark b o u n d a r i e s

tracks back until one knows all

skills of everyday scribe

volume 5

no single grave abides regenerate flume

nor
sign
want

greed

emptiness mind walking with girl

are
clouds
not
alone
 a h h h h h h h h h h h h h h h

frames

daughter
teacher

 full
 breasts

 freely
 given

 same such rain in day
 rubs rock this way

 we are here

accountable when did the moist arrive

 or go into
 no two a like

 early girl

her laughter
flowing

every step mind attends

 word invent

 liken
 breath
 to
 know

 is only
 meaning

 never
 taken

 what or where or when
 p r e f e r r e d

 stick in hand
 defines
 stone

 first wet clay
 same mother i write into
 purest simplicity story

 wrap-around arms as into her
 sudden let-go screams

 along the sligo

 bed rock and perfect stone
 faults runs through

 celebration

 set back bank waves air wet lips

 wet
 on rise
 longing
 creek flow s into

desire

thick mind smitten
wake and walk back letter from

she wrote on envelope

wrong way address

sometimes stupid mind

practicing wrong walking

only
foot prints
coming going

jealous husband

what are you giving to mind

who is mind

what is mind for

beg beg beg language to describe it best

just beyond outside
10,000 symbols

eye s tiny jump

go away doantrang s
shadow for company

no bear
no horse
no deer

only night
image in
countless ways

strings attached
to shape of

mirror rock

yes

yes yes yes you are p r e t t y

pay attention now

new thinking
more so swimmer

ka

everywhere

roll s up

cute

p
 l

 a

 sss

 hhhhhhhhhhhhhhhh

 l e a p s over rock bhang

 draw with her blood

 does not lay there telling

 fortunate story stone

 potential
 for a
 nother
 naissant

 odyssey

in a moments opening what is said is written

 she is pregnant

 oh thank you

red dust
hot breath
longer line
bridge near brilliance
shines

mouse mouth
wide

moist
words

w h a m

fire is low images
into darker recess

kiss stone
very long

until iron
in hands

fill
is
also
maybe
burns

 stone review

 best way
 through

intention

right
now

even

the
now
that
is
an
history

from here to there to all is remembered
 and chiseled into planks

 pieces
 know

 better
 make
 more
 babies

 e i
 b g n

 in
 wind

oh pray is in the open

what rock speaks
speak

to
the
dead

find
and
say
and
swear

there
attach is to
swollen tits

 a present view

her
run
towards
fresh air

stone nearly
twelve feet

tall
plum
lip s

full pout

pour is to fill cup with give and take

red wine

same
such
orthodoxy

in wax
in stone
in schist
 bring to by
 messenger

here
gone

nor
struggle
 rough heroics

lit
candle
 set into crack

strung glass
beads round
waist
 dance round
 hip s
 twirl

walking
girl
in
soft
embrace

nnnnn nnnnnnnnnnnnnnnnnnnnnnnn

 charred stick brings symbol
 from there here

 origin

 kadosh

 dust
 smear
 ritual

dead
wants
most
important

love

 radiant

have
in
every
direction

y e s

take to see
drawings in
her own hand

oh dear

she has him write

i am often
confused by your too fast
 abruptness

 for all of your
 walking

 where
 does
 mind
 come
 from

from here where does it go

 i just do not know

 silly me
i am just a stupid rock

 today we are here

you are here
i am here
baby is here

five poems for

30 days
she is
and yet the lights burn

from the rocks
foot prints
coming and going

swollen
ranting
and
raving

trip
yet
into
mountain
longest
kiss

ouch ouch
again stubbing
toe

ignorant fucking r o c k

baby
also
purple

moist

wet

on
lips

on
lap
curled

lucky
to
be

p u r r rrrrrrrrrrrrrrrrrrrrr

content

stones of love

step
is
care
ful

deeper
into
what
follows

equates

single
stone
amulet
just what
be tween
beginning and end

find in perfect irregularities

d
e
e
p
e
r
in
to

it s

e n t i r e t y

after
all

it
is
only

one

girl

one
wave

gem
is
just

stone
in
flaws

cut
through
it s

 authenticity

 mai lynne tu

 go is into crawling

see
everything
in
flame

 mind bison

 peeing cat

 own

 s h a d o w s

 dancing

 treasure this accident
 just as she is

 step aside mind
 not so easy get is back

 to this she begs
 it is not my fault what

 is fed and present frenzy

 only
 what
 gotten

 is

 eaten

 write there so easy of

 o dezzz ag brrrrrrzzz i

my eyes are happy to see you

you are looking with your insides

making me a better swimmer

so much
love giving

practice thumb going in first
pull a handful of water glide easy

ahhhhhhhhhhhhhhhhhhh that
 is
 it

who
needs
y o u
every
day

 my daughter
 my husband
 needs me
 want is also me

need turns my face angry

 lava
 rock
 firm

everything is light and dark

 shadow
 of
 girl

hot
round
fast

 dancing

along the sligo 2

 sudden
 view

 yellow
 gneiss

 there

 where
 the
 bank

 slips

 she
 flicks

her
short
black
hair

tawny
sunlit
back

bob is
in
stream
in
mind

 delight full

 follows

 authentic beauty

 just
 below
 surface
 ugly

 mind
 stone
 meet

prepare
use
ink
stones

last
two
dip s

into

a
single

he eats her sex

d
 e
 e
 p
 e
 r

stop is to sip
from her cup

scratch on wall
her back

stick
in
girl

minds
in
stones

trans
fers
from

wall
to
earth
to
hearth
to
lay

in
perfect
union

one
stroke
keeping

swim
up
with

what
develops

written

zzzzzzzzzzzzzzzzzzzzzzzzzzzzzzzzzzz

 small
 palette

 primary
 colors

 hold is
 shades of
 words

 on
 cup

 tradition
 is
 link

 is
 ceremony

drip of

 ink
 what
 heard
 done

mind walking through sounds of words

 stone
 mother
 presents

b o o m

 had her
 early

 who
 is

came
out
head
first

continuing mystery

 love only
 makes any
 sense out
 of

 what
 is
 evidenced

much as
ind

in
beauty
sees

stone
hag
begs
to
open

imaginations

seeing again and again and again

necessity

outside
wind

inside
stone

realm s

nor
single

cloud

alone

a
l
s
o

drifts

cross winds blow

cry out lang is mother e pic

 not copy
 in
 stone

 everywhere is everything

 is

 accident

 one mind

 thinking

 makes

 it

 s o

again kiss

try to objectify

r o c k

mud

luscious

no one comes to visit

only her
for

company

i was thinking

will i see you today

or is this just another

gone into pool deeper day

ordinary
makes
going
across
dingle

bridge
tears
in

eye

pregnant
jump
in

dance
madly
full
moon

just
as
you

are

next
moment

not
certain

get
lost

in
it

sound fire hearth body jiggle

within
rough

this

silence

warming
two
minds

dawn

melts

into
twice
her

age
what
 she

prefers

likes

what
works

what
satisfies

oh please

 spark
 makes
 of
 with

 u s e

z o w i e

 only
 just now
cut
into
stone

 what now is required is done
 .

 an
 agreement
 reaches

 i want to touch you

 want is sign
 written in

 moist rock wall

 mind is touch

 all so basic explicit form

 what shape anyway
 form is of nuptial

how did we get this far

where are you takeing

walking
girl

cool
clap
hand

one
sound
bounces

all over mind

d
r
i
v
e
n

palm
slapped
mouth

.

always open
lip pucker gets
more so

designer jeans

get
one
hide

into
sexy

 pull down

 w h e w

 this

natural rock figure

any chance we can finish this

difficulty beginning

inside

such
largeness

speaking writing

girl
too
quick

perfect woman

 tilt head
 this way

 that way

 moon

 then

 dawn

 rise
 above
 any

 lower case

 written
 suddenly

m e l o d y

metaphor
in fire
struck

granite
scratch

stone

 red
 blue
 yellow
 green

 tawny

 not so easy leaving
 not so easy coming

 red
 not
 yet

 ready

 marry me

 no more
 waiting mind

go away only

two one thousand times

 feet running

 go is into

 green

 enticing

 i

 this

 that

 dear doan trang

how are you and baby
six months old
i bet she is very b u s y
and you are not just being
her cow
glad that you
are
asking
 only stupid stupid
 no meaning answers

sometimes it is not easy to tell who

 baby
 looks
 like

 can be seen in

arbitrary
struck
symbol
makes

heart
mind
you

 o n e

 on

 story
 tablet

 where
 sound

 is
 written

rock beat
on
drum

 stone girl

words
in
mind

 hearing
 newness

 rising

 finger tapping on mind
 one symbol at a time

am i stone girl

without hesitation

in this
suddenly
lost

poem

who is writing

footprints leading

in all directions

far away
hearing

flute
sound

blowing

blowing

wind sounds

through
hole
in

mind

same
adequate
turn is

just
below
surface

get
key

finger
ring

hands
hold

easy

in
her

word

 i do

 i

 do

 kiss top
 kiss bottom

ooommmmmmmmmmmmmmmmmmmy
yuummmmmmmmmmmmmmmmmm

 mantra

 dance

 c o m p l e t e

touch
smack

where

sound
is
all
word

much
fuller

when
mind
slows
down

catches
meaning

you want me to write l o v e

sudden baby sneeze

then mind

want want want want want want

o i v

j
u
s
t

here

that what is form is empty of
that what is empty of form is

 sound of kissing

 version of # 2

all
these
words
sound
better

so
much
so

when
mind
slows
down

her
head
nods

below
surface

where
they

meet
in
dream

girl
throws

off

bed
rock

go
follows
what
seen

through
mouth

hold
shifts

typo graphics

reload
brush

walk away moment

sepia nave zenith
keep mouth shut

practice
free form
stone mind

sudden accident

in
ground

in
the
open

she

s h i t s

 such would and could and does

 lighten

extra
symbols
not
saying
 just
 what
 is

get
on
with
when
and
 after

 wall
 painting

 image
 looking

one kiss

beginning
every way

attracting

best
keep
tongue
in
own
mouth

wait
for
her
readiness
signal

who is doing

does matter

no need
to measure

meaning
seeing

 shove
 in
 to

fertile
stone

garden
in
her

seeded

 k i c k

 becomes
 proof

 what
 grows

 is
 reply

stone mind
replaying

answers

caw caw caw caw

k o k o r o

 k o k o r o

kokoroarunite

first time gone from

walking mind
seeing
smelling

count one
count two
count three

semes

at
once

most heart

felt

full
on
mouth

kokkie san stone k i s s e s

w o w

yambuki color

her
skin

and
open
flower

mounted

yellow
blossoms

on
stone

not
same
want
as

seed s

sown

into

mountain

yama buki thunder

mountain
play
with
wind

with
rock

old
mind

knows

what
to

do

ahhhhhhhhhhhhhhhhhhhhhhh

such
much
clucking

s
o
u
n
d

in

language

love is nesting

know is anyway that gets her pregnant

she and he
are
that
what
of

all
is

walking mind
opens

perfect circle

song

 means

 more
 so

 every

 sound

 one
 tablet
 cracking

 only
 white

 can
 shatter

 adds
 what
 is

 freely
 given

 without
 asking

 impossible

position

more
child
like

glee

stand
alone

one

leg
up

dance

round going laughter

dancer
is

again again

surely in our posture

before after
either in

gather

heat

leaves
it

so

where
it

 will
 make
 no
 more
 until

 baby
 tells

us

how
high

to
leap

taking
long

slow
walk

with
doan
is
to
stone

what .
ring
is
to
mind

feather rock implores

cah cah cah cah

union

strike

is
call

answer
birthing

on to pool

suddenly

she
shows

herself

flip
at
wall

stone pushes off

l e a p

 p

]

 a

 s

 h

 blind rock seeing so well

 yeah

 o k
 wasting full moon

 smooth through water

thighs
strictly
clearly

hands
go
in

 american mouth pout
 slow burn

 r a g e

flip is in her
glide

she
hits wall
where glyphs are
moody made

 i wish he was dead

 who

 lazy husband

 i
 see

 no

 mind
 does
 not

 see

only
what
imagined
becomes
seen

 you are what you have
 written

 better say
 no time for

 me

fooling

myself

.

drum roll

dance round

song coming

beside
her
self

going
into
whirl

misty
eyed

just as

right here

not going

far from
fire
far from

stone
girl

walking
mind

 warm
 circle

 word
 writ

 how

 further
 into
 this

 lily pad
 lotus pod

 stone erection

 every possibility its exploration

 love the slimy

 literal
 myth

 full stone

 echoes

 it
 is
 now
 an

 ethos

 big bangh

 when were
 you
 ever

 nine
 somewhere

 in deeper

beside
her

 nine
 months

 go
 for

 full
 term

 pregnant
 rock
 .

 tone
 in
 girl

 moon
 in
 fullness

 .

words take walking happiness mind

 stone red

 frills
 surround

 thrill

 mind
 has
 eyes

 open

 an
 art
 is
 when

 she
 breathes

 what is
 w r i t t e n
 comes
 through

 full blown

anemones
spray painted

on wall

either
matte
or
glossy

ok mind

form s
down
pat
has
lay

on
slab

gently

one verb
absolute

read into stone story chapter is verse

black figure motion left to chance

nor single deviant scepter takes

stone
girl

white
dress

black goddess

dawn
awakens

moon drift

does
not
deter

moving

child
thinking

she
is

a cloud

did mind write this

oh bang

mind
fluttering

swaying
tablet

her
h i p s

lah - la- la- lah- lah - la

hao bo moon

layering
beats
drum

mind
stone

butter fly heart

beating

beating

being

continuously
shifting
beginnings

simultaneously

two
practice

same
way

warm
lights

yellow

with
newness
ink

finger

draw

line

rock

shapes

one

every
thing

happens

take o k
give o k
want o k

need o k

o k desire

just ask

walk

story
stone
writes

when finish moving
rock from there

here

move

again

from here
to an other

when
thinking
that

 you can kiss my

 purple lips

one true stone
you hear without
ears

 song in mind

where
everything
dance
slows
to
walk

 radiant mother

 lead is out
 and public

demand

is

recognition

.

some same
doan
trang
swim

cold water

just back
from
lapping

hoot
over
long

vision

let is go
into

mind

walk
every
where

even
let
string

untie one
way beauty

 practice

 her

 freedom

beyond
squawking

mind

two
are
one

swim
out

warm
water

 pretty
 good
 method

 tiong chunhoo

 too close
 also
 needs
 already

 now here

 hot rock
 just so

 silly mind

 owns

nothing .

mind just trying to keep up
t h i s high more for what
need is hard on

ceremony

feet

rhythm

words

stand alone

what makes love is everyday actions

today is a fine moment
for ordinary walking

baby steps

from each
subsequent experience

coming going

when
fire

l i t

all images

clear

other only
private path

stone is game

breath in rock

as
long
as

now

silence

chance

change

e e e e e yyyyyyyyyyyyy

uuuuuuuuuuuuu

one
kiss

one
more

let
go

scream

kick

what did you say

same mind
thinking

makes
so much

h e r

continuously

every	yet	on
day	one	gray
this	picto	slate
or	gram	full
that	coming	moon
two	up	signs

everyday stone girl review

doing
seeing

girl
reveals

full

mind

in love with a rock

in the open

walking is honor

sudden
answers

stone nature

everything keeping

morning sun

march 23, 2006

deep in cave

dawn

inside
words

hum is in a whisper

dawn in red chamber

song
is
all
into

ear

word
dance

breeze
dancing

leg
dance

blossom

in
the
wind
dancing

 just
 so

 gaze into

 her eyes

 reflection

 naked
 in
 everything

 stone girl p l a y

 together

 depends

 then
 why
 this

 embarrassment

blush
because
you
are
behind
your
words

ftvne virl

what if
in
reaching

down

you
suddenly
found

that
you
are

p r e g n a n t

to make any sense
out of
leaves

this need to
 sing
 dance
 embrace

deep
inside
mind

home
around
again
in

belly

 only
 wave
 moving
 to
 birth

 girl
 opens

significant
meaning

nothing
meaning

everything
meaning

stone

girl

take

perfectly
clearly

mountain mountain mountain
river river river

we
call
her

by her

real name

walking mind
dropping
making
differences

stone girl

now and then
embracing

suddenly

pictograph
is
idea

all these
years

thinking

mind
in
head

stone
in
heart

every
moment
vocabulary

need
want
desire

purest invention

dawn makes

beside
fire

warm
she
serves

move
ment

 attracting

mind
mind
walking

girl
exciting

touch

 flame

 dazzle

step
in

over
head
under
water

swim

cave wall # 2

elegant
run

swell
leg

fast
mouth

purple lips

present

review eyes

nothing
makes
sense
as well as
anything

make
is
sense

or
any
other
else

more
so
makes

ensemble

crossed legs
sink into

easy
into
her

p u u rrrrrrrrrrrrrrrrrrrrrrrrrrrrrrrrrrrr

oh between
compatibilities

walk sing
mind stone

living dying

girl verbs
with charred stick

struck

the ancient way

 stone break
 is

 according

 way does stone sing

 nearly

 surely

 animal
 fat added

 makes
 candle
 light

 passage
 through

 visible
 go
 deep

into
cave
into

i l l u m i n a t i o n

fingers
black

bone
picking

turns
from
ash
to see

her
nurse

in
her
arms

in
his

mind

intra
play

only
seeing
is
with
heart

is

falling in and darkness going

mind remembers when and where

 their
 mutuality

 complete

 arousal

 congeries

 gate
 hinge

creack

from
here

difficult
to
mineralize

 try
 this

 no
 pretense

 shallow end of pool

 flip at wall

 s
 m
 a
 c
 k

 replicate scream

bring
is
breath

with
first
birth

 she stops

 my daughter need
 is me my husband
 need is also me

 i am just a cow

 thank you for making
 me
 a better swimmer

 we are lucky to be

 stone girl puts on her

 go away face

prepares
to swim
another

set

 push
 is
 off

 wall

into
mind

forget
what is
already
seen
or said

written
out of

sad

language

spoken

usage
left
as
record

delve
is
in

without
hesitation

look

for
some

a h h h h h h h h h h h h

taste
fresh

what
mind

eats

. eat

not wearing
wedding ring

signals

wet from swim

i wish he was dead

maybe smile
fades into

all suffering
innocence

into
going

 d
 o
 w
 n

feel
is
touch
too
quick

self
is
her

more
same
here

out of
her
element

swim
short

deep
chill

 suddenly
 this

 on na
 no ko
 iwa

 ko ko ro aruite

stone mind walking girl kiss sing kissing

 wearing
 patience

 ho hoh ha hah ha

 you thinking that

i will write

how are you and your language coming i am
fine but my eyes are sad because they do not
see so much of you it only confuses my walking
mind
 when working in stone

 take is all carving from baby
 then you will make a
 just don t know any thing

 mind
 is all

save our
letters

when mind dies sell them for enough money
to get a divorce move back with baby to your

afterwards
a rules arise

let them

stone girl how animal lives
and two feet lands on solid ground
tawny in this light every direction

comes out i m a g e s
gone into let

mind is heart

infant is pebble

squiggle
difficult
word
to
modify

tung hsin

mind & heart of child

now
go
to
pool

cold
cold
water

glowingly
into

 arrive is
 r a d i a n t

 temple stone
 in every
 step

 walking
 loves
 rock

who is it
anyway

who wins
and
what is prize

 fiction becomes what is

 some things words
 otherwise define

 all over sense

 seeing
 tasting
 touching
 feeling
 hearing
 thinking

did
he
ever
offer

with
in

or
with
out

getting

 break away rules

 in
 this
 the
 cut

 is
 deep
 into

 everyday living

 each moment being

return
to hold

first surprise
fills primary
inception

 just
 like
 that

 not a

moment
too soon

exactly

.

 a girl
 insures
 next

 generations

 choice
 chance

 each
 one
 follows

 use rock to break

 into opening

 possibilities

 coming going doing saying

 what needs want desires

 one by one as we are able to

work

virginity

only
drop
fear
of
winning
losing

what
is
thought

makes
fast

copy

 mind

 comes

 voice
 pierces

 long method in

 ancient symbols

struck
in
stone

every
subsequent
other
 tied
 to

 movement pictures

 watching

 waiting

 happy body

wet from pool

delightful

with
eyes

mind
hears

look at me

my big big belly
in there kicking
noise listen

we must take care

of no name fetus

baby
is in

l
o
n
g

l
i
n
e

o
f

giving

root tap

d

o

w

n

there then
here now

same moment

is more persuasive
is center
going out

names written

with hands

no merchants
barter is necessary

noddy swings towards

lightening sheet strike

sudden

waking

makes

hello

what is the problem

nothing much
i am just a little
baffled by your
meanings

did
this
poem

call

precisely
from
your
heart

within a
context

every
thing
begins

with

asking

do you love me

 am i
 stone
 girl

truly
things
sent
attached
to
letters

returned

written above
name and address

 moved far away

was it in my hand writting

yes

it was a big
mistake

send
them
back
to
me

 my treasures

 tears
 in
 eyes

 cinders
 in
 voices

 with
 cry

 come
 up

dawn

city girl

centered
 figure
 viet

counter

 what
 is
 left
 is
 nothing

 empty

 sustain
 is

 also
 stone
 ware

 used

tongue
is

into
wag

making us better

l o v e r s

continuously shifting beginning

without
warning

without
explication

stone record
shared

rock who knows

her

own
true
story

not so much what is said

as what is in and out of

 where
 opening

 slow

 drop

 c

 o

 n

 t

 i

 g ere

open language no lies no memories no necessities

tracks back to
what said and
to whom

as
some
pissing
canto

an accident
begin
is

in salt
water

e m b r y o n a l

boats

last
of a
long

l

i

n

e

a

g

e

walking opens

sight
of

stone
girl

in pool

first
splash

awakens

d e s i r e

silence
in
her

taken

stone mind touch

purple lips and ling am

 gone
 into

 d
 e
 e
 p
 e
 s
 t

 o h o

peer
is

birds eye view

in

 many

 ways

mind
goes
walking

two

three

 words

 found
 in
 torah

 in
 stone

laws await interpretation

taking

own
shapes

 needs i
 demand

 blank stone

 inclusive image

 f o r m

 attunes to

 s i z e

 shows
 what
 of

 you
 let

count baby

toes baby

f i n g e r s

 here
 all

 there

 breast
 milk

 shape
 also
 demands

 inclusion

toy

drum tickle
sound of rock

hummmmmmm ssssss

melody
delivers

inside
cave

fire

inside fire
center

warmest

toe tickling

laughter
on
reverberates

echo s
bounce
back

mystery

original
shape
color s

her
lips

every
where

speaking

symbols
union

run
is

time
to
scrape
away

grime

leave
shale
in a
heap

girl mirror
deep in rock

when she
smiles
roll
is
is

offerings

she brings

bring is in
her
stone cup

red wine

aglow
go is into
moist passage
way through

moss floats
in animal fat
a flame lighting

penetrates

she
before
him

in
the
moment

 celebration
 is
 congress

stone

d
o
w
n

around

jump

i
s

i
n
t
o

heat

run is
into

f e l i c i t y

offerings
muffled in moans

in gurgling

stone
is
so
much
mind

writing

words
 kisses
 pictures
 yes

d
 o
 w
 n

in
tend
is

to
under
stand

comunication

head first
mind first

arched
across

this

same way root
stone
hold is

living in

here and there
then and now

same moment

poke is more
assuage than
risen

lead
is with
eyes

where
writ is

also
signal

innocent noddy
swing to is dance

lightening sheets strike

sudden waking makes

i

 n

 t

 o

sort accorded size

do not send me any more
flowers

call me on my cell phone
when you have something
to communicate

your poem
will have to wait

it can come
after i eat

 wild
 straw
 berries

 not
 much
 larger
 than

 her
 breasts

love the juicy

walking mind
sitting on

outcrop

stone girl
blowing

anemones

 to say
 how far we
 have moved

 say it so
 stumps
 in
 back

 yard

 watch

 wait

 cultivation

 precipitates

 rot ting

 what is hurry up for worms

instead of
pointing to
head

point into
mind

where mind is

heart is

 let
 go

 of
 it

it is not so
easy

all of
these
countless
kalpas

writing
love
poems
to a

stubborn rock

next
thing
mind
knows

walking
milky
maidens

with
no
color

only
this
for
company

c r a c k

egg

double
yoked

sunny side
up

another
d a w n

black
goddess

green

eyes

just
watch

wait

until
slit

opens

blood
on
sheet

never
did
get
through

 every cycle

 you are here

 dive down
 kiss wet

 turn

 in her
 eyes

turn
in her
naked

arms

l a o

music

as
into
her

come
is
without

hesitation

emptiness mind

sweet sleep

in cave

cairn
marks
entrance

into

mother
realm
comfort

beyond senses

touching
seeing
smelling .
hearing
tasting
thinking

upright bactyl

marks
of
beauty

fullness
breasts

fullness
hips

sing
dance
leave

perfect circle decorates

absolute

k i s s

undressed stone

heralding

far beyond

far beyond
fear mind
makes

mis
taken
half moon

stone
comes
round

through

full
and
open

windows

get is previous
to
do
what
to

w h o

red moon risen

 tap

 tap

 t
 a
 p

 p i n g

boo
stiff
bam

 root is deep

 purple lipped ripe girl

 first

 cluck cluck

 who is what to whom

 not just put

into
demands

 her reputation depends upon

 what visits habits
come and see

and let it go

dance to the last note

viet mein

on
her
own

full
with
symbol

since
puberty

all over
all over

oh taste

 six
 senses

 just
 right

 trang

day and night

 dip

 into

 cold

 water

stone girl poem 3 737

pretty

love
makes

old hag

stone

ya ma

yo ko

yoko ono mama

each
kiss

on
full

purple

original

first time
touch

oh baby

flint
stone

fire
maker

love
is

so

often

original

undressed

suddenly

eaten

poem for dawn 13 906

mind
got

inside
rock

her
self

where

smile

drives
him

further

into

sitting	sitting
thinking	thinking
saying	saying

just do not know mind

if
rock
is
illicit

log fire
warms

entire

knowing

flare
up
is

no right way for this to go

strike
single

event

stone review

drum
beats

sacred
going
rhythm

patterns
in
method

production

in waves
historic

sunup

walk towards mind rising who is in sound
and written hitting mark is meaning

mind is rock

song is love

inside fire stone girl

now
dance

skirt
hiked

speak
in
foreign

tones

familiarity in the open

safe in embrace

i am lucky to be out of saigon alive

all
of
this

e r o s

bed rock

single
image

surely
written

ohhhhhhhhhhhhh hhhh hhhhhh

marks on wall

stone

fertile

enter
two
times

again again

again again

just so
j u m p

from mind to rock

write
concurrent

walk with feet

with rocks with

absolute reverence

stone goddess

go down
hear touch smell feel

kiss

in
mind

grin
is
from
ear
to
eyes
to
accomplish

old
bonze

old
hag

warm

water
pool

what be
gun as
grunts

first
words

mean

look in eyes

worth
10 000
words

no
thing
is
so
simply
made

thinking
making

wake

to
say

i am
in
love

with
a
swim
fast

stone

pregnant

what did you expect

be
for
e

in
vent
ion

of
alpha
bet

have not seen a rock like this be
fore and i have seen a lot of
rocks

love poems sent

what was her reply

keep it up ed

salutation s kiss to kensington

neolithic s late news

tonight

so
effectual

savvy linguistic
make
skip along

simple
notes

i am too
busy
for t h a t

she
round
kitchen
midden

brings
into
practice

little fingers playing touching

arms
swing

nod
is
flip

 this
 way

 that
 way

lips hands hair

c o m p o r t

pride
rides

horse
on
six
legs

fast her go

girl a woman is

h u mmmmmmmmmmmmmmmmmmmmmmmm

scope

timbre

writing

corresponds

pubic triangle

hold s

predictability

much every
thing change is
her new bikini
tiny top thin belt

tawny accentuates

bought for you to see
new swimming suit

that do you think i am
too pretty in abundance

walking through my mind makes it so

mourn
ing
swim

to
gether

light
in
eyes

laugh
in
splash

every other
stops to watch
us speaking

giggling

listen
to
chatter

sound
of

on
moist

lips

absolute

go
is

 to
 get

 a
 better

 view

 dawn
 arrives

 i say what
 can be said
 written
 in a line

 exactly

 on
 her
 back

 see is
 another

 angle

 she
 asks

 gives

only

what
is
yet

to
give

g i v e n

stone
sees
mind
sees

face

wide

grins

short black hair
flick in frames

nguyen

tel
is
of

an
d
round

protecting

baby

kiss
is
sure

rise

is
rapid

 three pebbles
 in the ripples
 touching

stone of everything

 chambers
 in
 side

 where
 for a
 time

 pause

 is
 play

sculpts

lake
is
gentle

care
is in

husbandry

all things provide sudden leap into warm water
freestyle swim strokes glide bodies through

olde bonze cut fast young is into rock mud luscious
old hag here sixty five years there thirty five years
stone pibble with excitement just here he slides

hands under water under arms from behind lifts
 above still water tawny hips slip is against

 s m a c k

 settle is into l o n g s l o w g l i d e

rosy violette

found

walk

flush

d o n e

any
way

each

its
own

hold

mother mind stone walking

match
stone
scribble

wet
goddess

breeze playing

beacons

scream is birth

c r y

o u t

next
dive
precise

know
is
familiar

into
center

only
what
is
given

swim is long time

s o n g

do you love me

 unlike
 say

 jade
 ear
 rings

dangle

farther
back

pulled
hair
 to
 get

 tease

 love the juicy

 its
 geography

 head and
 tiny breasts

 bodhi satt va

 tongue wags
is
to
lips

puckered

 suckles

 fully
 on

round
bends
it s
glade
&
glow

she is sooooooo

viet nam

drives a b m w

married young

a chinese jew

escaped by boat

her father

imprisoned

tortured

noodle
shop
lost

who is
given
luck

good
or
bad

gives new meaning
to
eating noodles

my husband does not
make so much money
he only likes his little
boat what is this luck

takes on it dumb young
girls
who work in my fingernail shop

he likes their painted
toes and lips
the red means
to kiss me

never go on little boat

wish he was dead

countless eddies swirl

w a v e r i n g

not
same

one
stone

say
ing

yes

ye
s

 y e sss ssss

now
walking

stay away pool

 o
 n
 l
 y

recent
cold water

leap
from
this

time
to
finish

polishing

stone

gets
up
fire

by
light

warmth

drys
off
all
over
body

where

wet
is

she
leaves

mind
practicing
perfect
virtues

next
moment

shadows

tell it

so

depending

goes on
horse
back

ride

full gallop

over
bare
rocks

freedom style

 on the way

 slow prance

 she
 pushes

 sold
 out
 sign

 aside

after
all

nothing
always
change
is

everything

be gin
is
again

continuous

walking
writing

stone girl e-pic

oh so

touch
where
in
this

lay s

straight
line

mi mosa
pu dica

mim
oh
sa

touching
getting

all
of

to
keep

to
want

to
mind

yet
here

where are you

where did you go

i wish that i could

no one comes to see

touch me here

 hold me

 stone does
 not
 pretend

 all
 in
 this

just what is

final
in
that

context

story
surprise

booms

 silence
 break s
 into
 laughter

 one
 kiss

 authenticates

 change
 is

more no buy
than jewel is
stone worn bmw

girl	in	husbandry
nor	the	is
walking	open	lazy
mind	needs	does
not	basic	make
wound	survival	money
only	learn	again
part	to	like
red	lips	boat
painted	toes	from
saigon	teach	mailynne tu
lucky	to	be

all so free of businesses
run wag is here where
eyes meet

dog
barks

happiness mind

swim
wagging
tongues

stone
fully

seconds
kiss

toward
mind

door
swing
in
and
out

both
ways

open

up
in
smoke

signals

what
is
inside

feelings

float
upon

clearest
honoring

what
done

and
their

location

are you waiting for me

only
just
now

legs
arms
chest

lips

lift
up

where
eyes
meet

go is
into

basic

stroke

down
pat

glide
be

gins
hands

pulling
body
does
not
disturb

water

 punctuates
 her
 concentration

between
fingers

pull
is
through

twist

after
all

it
is

only

one
wave

plunge

long
fall
into
fault
can hardly
say what

feelings
make

is
more
so

made

just as you
are
mind also

 showing
 herself

 can
 hardly

read

what is
written
along
this
line

makes
more

storied

 play is with
 gentle touch

 every
 thing
 else

warfare

fullstirringsuponherbreastsucklinggirl
fullshebetweensighsonlygivelifeandgo

walkingmindlostinsfullmousemouthheart
andsoulinheryesthirtyfiveonthewayfeed
mailynnetuchoicewhatmothercowsudden

 gifts
 full
 between

 the
 ripples

 laying
 hands
 on
 hips

 swell
 in
 belly

 takes
 all
 attention

 stone
 reflecting

rock
made
doing

mind
girl
knocks

on
door

rapping
opens
with

boggles

 to
 know

 to
 say

 to teach
 is an
 equanimity

 to get hang of
 more difficulty
 between

 ending
 and
 beginning

perfect
enso

noise
&
nattering

screed

nesting

deeper
in

mountain

third
one

now
all

birds
bring
ing

worms

cheee cheeeeee cheee chi

purple

blue

purple
blue
yellow
green

white
tawny
flower

clearly
visible

 stone girl
 wild orchid

 full moon

sacred
color s

deep
tones

everywhere

 dawn

 comes

 through

as if
walking

could
satisfy

ahhhhhhhhhhhhhhhhhhhhhhhhhh

event
ually
she

will
say

what
is
what

beyond
peering

girl
mind

tip
of
brush

has
a
mind

of
its

own

dip
is

i

n

t

o

allure

straight
lines

why
pause

ah
ha

ha

together

new
strokes

all

same
time

rhythm

moving

some
same

rise

into
verbs

circumference

centering

surround

.

hold s

flower

in a

perfect

cracked

vase

classic rock garden

rake
can
scratch

dig into

soil

import
what
thought

what
is
done
give
breath

without
thinking

feelings
come

go

clouds

rain

stones

drift

partial

to that these long nights intrude

long run on

sentence

much more than go is far away

shape of lava rock

slipping fingers into
texture
turn s inside

night becomes

amorous

sun moon round

her
scent
on
breeze

suddenly

forgiveness
letter

arrives

mystery
past

```
            circle
            pulls
            into
         preparation

        song in stone

          entirely

this        sit         rock
is          on          with
right       bare        ing

place       ness        trang

          n g u y e n

is          into        hair
a           her         finger
man         short       flick
is          cut         ing
```

out crop mother pokes and tickles

red painted toe s
nails
in water dangles

try this

stone happy mind kick

lu lu ai ai ai ai ai tu

what neolithics

in
this

then
strikes

simultaneous

use
of

back and forth

all
contains

one
mind

one
stone

dichotomous

 where
 want
 is
 left

 light
 is
 way
 and
 seeing

girl
offers
cup of

wine

reach is

oh this
awake

with
dawn

pee
shake
stretch

jump
into

water

here we goooo

size
not

an
issue

swim

yet
get
is

final

as
any
other

song

did you yet get
that version of

poems

i suppose that you
want me to send
another love letter

 get is as
well as

fine tuned speak is

 stone mind

 single

 s l a p s o u n d

not so easy
getting to phone
on first r i n g

hello

it is
me

at this
end

i am just

testing
your
number

now
sending
ring

 carved out jade

small
words
written

in large
space

added
to
thicken

things

invented
dirt floor hut

stone mountain

emptiness room

farthest reach

what does blind
girl
see

 one kiss

 &

 i
 will

 tell

 some rock

 split
 down

 center

discovery

makes

baby

penetrate

perfect
balance

 form

 living

 stone

garden
opening
is
again

lay is

ripe

split
is
rent

shed
image

walking
abides

sudden
hold

is
tight

is

total

 tsk tsk tshoooo make is
 walking fingers tick ling
 sudden arching girl body
 bam boo mizzle shaking

 round

 fire

 dance

 every

 way

the
old
style

stone
in
girl

read
is
by

flickering

wall
glyphs
just so

sudden
clean
sweep

dirt floor

habitation
secure

it s community

story cairn
dawn manse
travel so lightly
red ochre jack
breezingly cave
cut through mountain
coyness mound
purple lips kiss
pick mind clearing
tawny badger fully
maulynne tu
jade ring sitting

feather rock dearly
rock of comfort
known for feelings
phan thiet noodle shop

circumference
surrounds

stand up stone
bound

inside
out

mind
flicks
very
much
looking

seeing
accidental
meeting

as
so
often
is

by
al
ways

in
early
flush

more
than

space
is

d
r
o
p ping

continual
whirl
into

what
is
limits

first time you go into me

see
only
clearing up

 this mystery

you mr walking mind

after birth

ablude

just
here

first
baby

lucky
girl

do not expect

darkness goddess

 metaphors

 in
 this
 real
 canto

one day
we will
look back

read into images

things

sing is

likely move
into
words

sleep

one
takes
steps

frees
up

more
than

limits

feather rock rice mother

d
 r
 u
 m
 m
 i
 n
 g

on skull

on belly

listening

i *am* here

65 years

old
mind
old
stone

cleans
houses
sweeps
thinking

warm
rock
expecting

teary
eyes

signifying
husbandly
vows

to throw
you
out

let him

at
least

you

will have a
c l e a n break

crackle

leads
mind

along

new
trails

soft
kisses

cave
with
chimney

fire
in
the
middest

their o f

stone
hearth

also

just
what

girl
brings

shared

red tipped sharp
bone in deep

symbols
delineated

split is swift
and
precise

between
feather
bed

walking

silver
glitter

flakes

rock

countless
eons
make

insatiable
hunger

saying

does
not
answer

enter s
into
stone

otherwise
written

twinning

just
there

2wo

twist
as
one

living
thing

wrought
of
purple
lips
voices
risen

oneshivabreathoneshhaktibreathafterall
onlyonewavelinescratchesinstone only

picture seeing representation of

clouds in sky

attachments
coming going

does not disturb this concentration

brings mind
essence

emptiness
form s

pattern

keeping
temple
where
bend s
to
light

bend

way
is

not
so
easy
granted

arch
across

dig

there

with

one
who

glides

further

further

just
into
its

pattern

after
stone

girl

meta
crystal

rock

closely

foliate

can
be
sp l it

 along
 approximately
 parallel
 planes

can
also
dig
into
her

actually

accorded
language

written

become

is

group
gather

centers
around

points

tell what does this

hole
in
stone

place
for
bone

in
wall

mark s
cut

deep

stone
goddess

means
measured

in
rules

often

with
eyes

wide
open

giggle

whirl

play
in

what
is
written

loving
image

on
wall

dotting

abstracting
things
as

permanence

here is representing
girls s t o n e s

walktorevealhertrueself

rise

i
n
t
o

tawn

daily

long
ing

purrrrrrrr rrrrr rrrrrr

beggar

comes

courting

long
slow
taste
word s

feed

tomorrow
without
worry
where will you
be

nothing
written
here

stone
matters

nothing

roils

what
in
tone

thusly
quaint s

up
glance
turns

pouting
image

full
half
her

sized

slide
 with
tongues
in
mouth
opens

to
fetch

figure
of

over
&
under

is composition

cutting
makes

one
makes

two
makes

three

kokoroaruite

walk
mind
ing

heart
feel
ing

thinking
loving
rock

done
is
in

chip

stride
and
airy

prance

sway
back

pony

ride
form

put
atop

familiarity

rock
clouds

mind
cloud

walking
girl

perfect
rhythm

grouping
symbols

other
petro

glyph

wild
dance

l
e
a
v
e
s

using

determinant

peer
tilt

head
towards .

shadow

so
close
that
mind

can
touch
smell

taste

her

clearly

contradicting

briefly
confused

his
look
is
to
get

a
better
sense

of

her
in
heat

rock
before
breath

who
says
now

and
what
to
whom

leisure
allows
creation

stone
girl

image

language

inherent

design
scratch
makes
shape

actual

so
much
extends

phantasy

story

watching

waiting

all
visuals

imagined

not
necessary
to
be

exact

cut
or
pin

d
o
w
n

anything

all ways

pay
is
full
attention

suckle
what is

instinct
towards

the
details

who
looks
to
see

who
sees
blind

needs
only

woman
salvage

bone

cave
is
more

come
is

in
to

gentle

writing
rides
wave

note
in
bed

rock

one
line
follows
any other

deeper
words
usage

determines

sounds
her
moaning s
make

change
is
easy

all
being

trill
and
roll

turns
to
see

 tracks
 back
 leaving

 no trace

bare
tone
re
visits

speech
less
in
what
said

than
what
set

there

within
each

drip

today
rain

a
fine
day
for
playing

stone
open
ing

mist
ing
eyes

every
bit

as
salty

taste
is
comfort

nipples
give

thunder
in
stone

accidental

she
sings

take
into
consideration

every
hint

without
calculation

instinct

walking
mind

step
is

into
how
to

satisfy

cut
is
off
of

slab

more
than

first

intention

eh ee ah owe ooooue

rock

essence

not
separate

from

look

wake
up

fifth

k i s s

moist
moist

change
change

space
allows

wind word s

hair play

wisdom body

pregnant
invokes

plash

swim to far end of clearness pool

flip is adequate

sudden

get lost in it

utpala utpala

 sweet
 scent

u p a s a s a m e y y a

 is
 absolute

 only so much body
 language
 known
 is
 eventual

knows or does what is necessary

sung young girl
effortless
as if she has

 asoka

 word
 sing
 stone

 s o n g

 as
 fast
 as

 ninety times
 three hundred

 times

ammma mommy yummie

ut pala ut pala sweet smell

upasameyya

shizumaru shizumeru yawarageru yowaragu

 sun
 rise

 look
 out

 dawn
 wears
 same
 fetch
 ing

 tawny
 suit

what
of
any
thing
if
walk

turns
heads

hot rock

vajrayo gini

change is same

integrity girl

gently
words

softly
spoken

just so many love poems to one rock

she passes
into
silence

sound
of
old hag

ringing

a way
in
every
measure

epics

words
not
necessary

black
flick
drops

lets
into
surround

 what in
 volves
 is seen

 pay attention

true
image
here

menhir

she
is
more

going

all
eyes

protrude

 some
 time

 hearing

 sensing

 kicho ui tugge
 ·kal mangnan

 pa ro

 chae bae ha da

grow
rout s
thick

cultivates
unfamiliarities

spring
orchid

 clip
 p
 ed

 completely

 new
 lang

 herein

 let
 go

 go

 everyday
 far from

ordinary

m a t r i k a

memes

yet
more
so

thought

symbol

only
what
she

is

full
moon

just so

just so

horse

same
set

in
her
put

in
her

come
around
with
needs

need feed

go to well
each
morning

mai goes
to
breast

great luck

when
want

 is
 plenty

 and
 lasting
 tone

 yet

 we
 have
 more

as
if
it
matters

 give is
 abundant
 to
 open ing

mouth
no
words

only
gurgling
deep

sound

written

it is significant

it just does
not
translate
so

adequately
or have
a single
meaning

she continued in
vietnamese

for me
thanks
for helping

some
thing

lost
in
saying

meaning

first
time
letter

says
it
so

swim fast
next

practice
practice

practice
practice

sudden
catch

one
wave
laps

 as
worthy
 as

and so
is
written

buy
into
a new
bikini

swim
for
you

to
keep
mind

b u s y

.

.

take seriously
with

splash in eyes

match and fit

perfect

of
course

another
horse

is
speckled

o h

this
ride

gallop

in
place

in
time

tone
is
want

what
if

suddenly

we
had
no
eyes

no
ears

no
mouth

no
nose

 nor flesh to touch

difficulty
think
ing

ordinary
comes
with

not yet
intent

throb
east
wind
bends

into

 life
 breathing
 this

 that
 is

 choice

 comes
 round

 a gain
 a gain

girl
is

look
into
heart